DRAWN FROM TRADITION

Bruce Weber

DRAWN FROM TRADITION

American Drawings and Watercolors
from the Susan and Herbert Adler Collection

Hudson Hills Press • New York
In Association with the Norton Gallery of Art

First Edition

© 1989 by the Norton Gallery and School of Art

All rights reserved under International and Pan-American Copyright
Conventions.
Published in the United States by Hudson Hills Press, Inc., Suite 1308,
230 Fifth Avenue, New York, NY 10001-7704.

Distributed in the United States, its territories and possessions, Canada,
Mexico, and Central and South America by Rizzoli International Publications,
Inc.
Distributed in the United Kindgon, Eire, Europe, Israel, and the Middle East
by Phaidon Press Limited.
Distributed in Japan by Yohan (Western Publications Distribution Agency).

Editor and Publisher: Paul Anbinder
Senior Editor: Virginia Wageman
Indexer: Gisela S. Knight
Designer: Charles Davey
Composition: David E. Seham Associates Inc.
Manufactured in Japan by Toppan Printing Company

Library of Congress Cataloguing-in-Publication Data

Weber, Bruce, 1951–
 Drawn from tradition: American drawings and watercolors from the Susan
and Herbert Adler Collection / Bruce Weber.—1st ed.
 p. cm.
 Exhibitions held at Norton Gallery of Art, West Palm Beach, Florida,
Nov. 11, 1989–Jan. 8, 1990 and Williams College Museum of Art,
Williamstown, Mass., Feb. 2–Apr. 15, 1990.
 Bibliography: p.
 Includes index.
 1. Drawing, American—Exhibitions. 2. Drawing—19th century—United
States—Exhibitions. 3. Drawing—20th century—United States—Exhibitions.
4. Watercolor painting, American—Exhibitions. 5. Watercolor painting—19th
century—United States—Exhibitions. 6. Watercolor painting—20th
century—United States—Exhibitions. 7. Adler, Herbert—Art
collections—Exhibitions. 8. Adler, Susan—Art collections—Exhibitions.
9. Art—Private collections—United States—Exhibitions. I. Norton Gallery
and School of Art. II. Williams College. Museum of Art. III. Title
NC107.W43 1989 89–83702
759.13′074′7441—dc20 CIP
ISBN: 1–55595–023–X (alk. paper)

Exhibition Itinerary

Norton Gallery of Art
West Palm Beach, Florida
November 11, 1989–January 7, 1990

Williams College Museum of Art
Williamstown, Massachusetts
February 2–April 15, 1990

Contents

List of Plates 6

Acknowledgments 7

Intimate Choices 9

Catalogue of the Exhibition 27

Appendix 172

Index 183

Photograph Credits 187

Plates

Works indicated with an asterisk (*) are reproduced in color.

Francesca Alexander, *Catherine and Cornelia Cruger* 29
George Ault, *Little White Flower** 31
William P. Babcock, *Female Nude with Cupid* 33
Peggy Bacon, *Lady on Front Porch* 35
George Bellows, *Lady of 1860* 37
Isabel Bishop, *Two Girls, Study* 39
Emil Bisttram, *Pearls and Things and Palm Beach** 41
Emil Bisttram, *Time Cycle #1* 43
Oscar Bluemner, *Venus** 45
Oscar Bluemner, *November Moon (Moonrise)** 47
Robert Frederick Blum, *Study after "A Venetian Market"* 49
Rutherford Boyd, *Self-Portrait* 51
Fidelia Bridges, *Flowering Vine** 53
Paul Cadmus, *Old Lady* 55
Mary Cassatt, *Study for "Young Women Picking Fruit"* 57
James Wells Champney, *Indecision** 59
William Merritt Chase, *A Countryman* 61
William Merritt Chase, *Mrs. William Merritt Chase (Spanish Girl)* 63
Joseph Cornell, *The Ocean** 65
Arthur B. Davies, *Prancing Nude** 67
Joseph R. De Camp, *Portrait of Peggy Wood** 69
Paul de Longpré, *Ramblers** 71
Thomas W. Dewing, *A Study (Lady with Flowers)* 73
Walt Disney Studios, *Mickey Mouse (Doden-Doden Da Da-Dah)* 75
Giuseppe Fagnani, *Melpomene* 77
Ellen Thayer Fisher, *The Orange Bloom and the Myrtle Bay** 79
Frederick C. Frieseke, *Morning Room** 81
William Glackens, *Gloriana! Come on, Gloriana!* 83
George Grosz, *Mann im Mond* 85
John Haberle, *Head of a Man* 87
Lilian Westcott Hale, *The Artist's Mother (III)* 89
William M. Harnett, *Iris* 91
Childe Hassam, *San Pietro, Venice** 93
Robert Henri, *Portrait Head of a Woman* 95
Winslow Homer, *Over the Garden Wall* 97
Eastman Johnson, *Head of a Young Girl* 99
John Frederick Kensett, *Standing Monk Holding Staff* 101
Rockwell Kent, *Gunfighter* 103
Rockwell Kent, *Woman with a Drink* 105
Rockwell Kent, *The Pearl Necklace* 107
Leon Kroll, *Head of a Young Woman* 109
Louis Lozowick, *Machine Ornament #4* 111
Louis Lozowick, *Smoke Stack* 113
Reginald Marsh, *All Night Mission* 115
Jan Matulka, *Still Life with Guitar, Pears, Wine Pitcher, and Glass* 117

Francis Davis Millet, *Lacing the Sandal (Lady Tying Her Sandal)** 119
Walter Murch, *Study for "Cyclops"* 121
Elie Nadelman, *Seated Figure* 123
Jules Pascin, *Feuille d'Etudes* 125
Jules Pascin, *Street Workers* 127
William McGregor Paxton, *After the Bath* 129
Theodore Robinson, *Reading (Study in Monochrome)* 131
Hugo Robus, *Beach Scene* 133
Theodore Roszak, *Construction* 135
Lucas Samaras, *Untitled** 137
John Singer Sargent, *Mrs. Claude Beddington* 139
Steele Savage, *An Embrace* 141
John Sennhauser, *Untitled* 143
Everett Shinn, *Reclining Female* 145
Walter Shirlaw, *Chemistry* 147
John Sloan, *The Couple* 149
John Sloan, *He Was Quickly Placed in His Carriage* 151
Sidney L. Smith, *Ellen Terry* 153
Saul Steinberg, *Saloon, Nebraska** 155
Joseph Stella, *The Puddler** 157
Maurice Sterne, *Girl Seated* 159
Albert Edward Sterner, *My Wife in October 1897* 161
John Storrs, *Female Head* 163
John Vassos, *The Bosom of His Father and His God* 165
Robert Vickrey, *Military Clown* 167
Frederick J. Waugh, *Three Furies** 169
Charles White, *Dawn* 171
Francesca Alexander, *Girl Holding a Locket* 172
Peggy Bacon, *The Swan* 172
George Bellows, *Lady of 1860* 173
Isabel Bishop, *Rosalynd* 173
Isabel Bishop, *Ice Cream Cones* 174
Emil Bisttram, *Untitled* 174
Oscar Bluemner, *Soho* 175
Alexander Calder, *Donkey with Horn* 175
Sante Graziani, *Biglen Brothers #2* 176
Robert Henri, *Blind Musician* 176
Al Hirschfeld, *Hair* 177
Al Hirschfeld, *Zero Mostel as Peter Pan* 177
Daniel Ridgway Knight, *Study for "The Harvest"* 178
Reginald Marsh *Fourteenth Street Girl* 178
Walter Murch, *Artificial Crystal* 179
Maurice Sterne, *Head of a Woman* 179
Thomas Sully, *Portrait Study* 180
Ernest Trova, *FM Collage* 180
Unknown American artist, *Yellow Belleflower Apple* 181
Unknown Philadelphia artist, *White-Haired Man* 181

Acknowledgments

During the course of organizing this exhibition and preparing this publication, numerous individuals have provided invaluable assistance. Above all, I wish to thank Richard A. Madigan, former Director of the Norton Gallery of Art, for his support, encouragement, and invaluable advice. Brett Miller, Assistant Curator at the Norton Gallery, has worked closely with me on all aspects of this project, as researcher and compiler of the material relating to the provenance and exhibition history of the works on exhibition, and as a thoughtful colleague. Before her departure from the Norton, Nancy Barrow worked diligently on various aspects of the exhibition, including the checklist. Pamela Parry, Registrar, arranged for the shipment of artworks. I would also like to thank my wife, Jan McLaughlin, for her thoughts and advice. Professor William H. Gerdts, Graduate School of the City University of New York, generously allowed me to use his library for research purposes. In 1977, when I was Dr. Gerdts's research assistant at the Graduate School, I authored the entries for the catalogue published by the Neuberger Museum for their showing of the Adler collection. Now, more than ten years later, I have again had the pleasure of working with Susan and Herbert Adler, who have been a delight from start to finish.

Bruce Weber
Curator of Collections
Norton Gallery of Art

Intimate Choices

Susan and Herbert Adler are among the most avid contemporary collectors of nineteenth- and twentieth-century American drawings and watercolors. Since the first showing of their collection in 1977 at the Neuberger Museum of the State University of New York at Purchase,[1] the Adlers have acquired approximately fifty works on paper, more than doubling the collection in size and broadening it considerably in scope. The collection began with Herbert Adler's first purchase of Leon Kroll's *Head of A Young Woman* in 1967. His interest developed after graduation from the University of Pennsylvania, where he attended several classes in the history of art. He was encouraged by Lloyd Goodrich, former director of the Whitney Museum of American Art, and the artist Moses Soyer. It was Soyer who advised him to focus his interest on American drawings and watercolors. Since Herbert and Susan's marriage in 1973, they have shared equally in the collection's growth and development.

At the time of the exhibition at the Neuberger Museum, the Adler collection consisted almost entirely of figurative works on paper by American realists of the early twentieth century. Now the majority of pictures in the collection date from 1880 to 1940. Over the past twelve years the Adlers have acquired eighteen American drawings and watercolors from the nineteenth century. They have also added a number of twentieth-century pictures influenced by Art Nouveau and Art Deco. The collection now features numerous still lifes and abstractions.

Drawings and watercolors of people most appeal to the Adlers. Images of women dating from the nineteenth and early twentieth centuries dominate the collection, because, as the Adlers have discovered, they are more plentiful in number. For the Adlers a drawing or watercolor of a person, whether female or male, has to be more than a good likeness; the identity of the sitter or model is not of principal importance. They favor pictures that convey a sensitive and sympathetic understanding of the subject's character and capture the dignity and nobility of the human spirit.

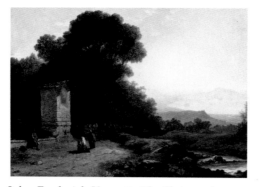

John Frederick Kensett, *The Shrine—A Scene in Italy,* 1847, oil on canvas. Mr. and Mrs. Maurice Katz, Naples, Florida

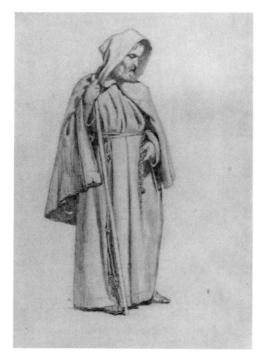

John Frederick Kensett, *Standing Monk Holding Staff,* ca. 1845–47 (no. 37)

Surprisingly, it is only in very recent years that private art collections have been formed in this country that focus on American drawings and watercolors of the nineteenth and early twentieth centuries. The Adlers have been at the forefront of this phenomenon. The first prominent American collectors of drawings, James Bowdoin III and Robert Gilmore, Jr., acquired in the early years of the nineteenth century contemporary European and Old Master drawings. Their dearth of interest in American efforts undoubtedly is linked to the fact that at the time American artists displayed little or no interest in drawing as a primary art form. The first serious and concentrated attempts to direct artists to the importance of drawing were made in the mid-1820s with the formation in New York of the Society for Improvement in Drawing, the New-York Drawing Association, and the National Academy of Design. The Academy led the way with the institution of a formal drawing curriculum. Soon drawings and watercolors became a regular feature of the Academy's annual exhibitions, although the number included was small in comparison with works in oil.

The earliest known gatherings of drawings and watercolors by American artists are albums exchanged by artist-colleagues who participated in the various sketch clubs organized in New York in the wake of the formation of the National Academy. America's first important and systematically conceived collection of drawings and watercolors by deceased as well as living native artists was formed in the mid-nineteenth century by Charles Lanman. Collections along this line were also formed during this period by John Mackie Falconer and James C. McQuire. With the founding in the late nineteenth century of such organizations as the American Water Color Society and the Society of Painters in Pastel, and the publication of numerous periodicals that prominently featured illustrations, American artists for the first time had a regular opportunity to market their drawings. Major collectors of the 1880s and 1890s, such as Thomas B. Clarke and William T. Evans, took special interest in the various exhibitions of works on paper. Further study of the American art collections formed during the period should be undertaken in order to reveal in depth the full extent of the collecting of American drawings and watercolors in the nineteenth century.

American museums began to form concentrated collections of American drawings and watercolors in the early decades of the twentieth century, among the most prominent of which were the Carnegie Institute, Cooper Union, the Art Museum of Princeton University, and Phillips Academy. During the first half of this century Maxim Karolik was the most dedicated collector of American drawings and watercolors. In the 1930s Karolik began his association with Boston's Museum of Fine Arts, to which he donated more than three thousand drawings and watercolors dating from the first three-quarters of the nineteenth century. In more recent years such collectors as John Davis Hatch, Jr., Paul Magriel, E. Maurice Bloch, George Hopper Fitch, Mr. and Mrs. Stuart P. Feld, and Susan and Herbert Adler have assembled the most significant and extensive private collections of American drawings and watercolors of early historical and aesthetic importance.

It would of course be impossible to discuss in detail all the pictures in the Adler collection in the course of this brief essay. Therefore I will single out those works that stand out as among the finest and

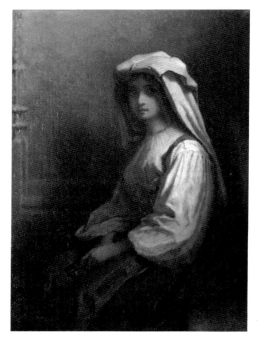

Eastman Johnson, *The Bohemian Girl*, n.d., oil on canvas. © 1980 Sotheby's, Inc., New York

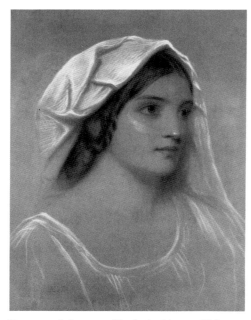

Eastman Johnson, *Head of a Young Girl*, ca. 1850 (no. 36)

most representative examples. Among the earliest drawings are those by John Frederick Kensett, Eastman Johnson, and William P. Babcock. All were executed in Europe and reflect American interest in the mid-nineteenth century in artistic travel, foreign study, and occasional settlement abroad.

Kensett was one of the leading Hudson River School landscape painters. His drawings were generally made with future landscape paintings in mind.[2] The artist worked in pen, sepia, and watercolor, but he preferred the medium of pencil, which best enabled him to render fine, sharp detail.

Standing Monk Holding Staff dates from early in Kensett's career. Executed in pencil in Italy in the mid-1840s, it is one of several Italian studies later utilized for his oil *The Shrine—A Scene in Italy*. The inclusion of the monk helps to evoke a spiritual message. Characteristic of Kensett's early drawings, the picture is tightly drawn and highly descriptive. The figure's contour is sharply rendered, and each fold of the robe and hair in the man's beard has been meticulously drawn. Using the side of his pencil, Kensett carefully indicated the garment's coarse texture and the play of light and shadow. In contrast, Kensett softly and delicately modeled the facial features of the monk in midst of prayer, leaning almost absentmindedly on his wooden staff. It has been speculated that the Adler drawing may have been executed in Rome at a popular evening class where students drew and painted from costumed models.[3] The class provided a source for costume designs as well as picturesque models for the artists who attended.

The American genre painter Eastman Johnson began his career as a portrait draftsman. The charcoal portraits he executed in Maine, Rhode Island, and Washington, D.C., in the 1840s established his reputation. Early in his career, Johnson regularly used charcoal and chalk in combination for preparatory studies. Johnson traveled to Düsseldorf, Germany, in the late 1840s to receive instruction at that city's renowned art academy. While in Germany he executed the charcoal-and-chalk *Head of a Young Girl*, which apparently served as a study for the artist's oil painting *The Bohemian Girl*.[4] The drawings that Johnson made during his stay in Europe exhibit a lighter touch and a better understanding of composition than his earlier portraits. Tonal transitions are rendered with greater sensitivity, and his characterizations are more evocative and romantic. Working on the warm brown–toned paper, Johnson quickly laid down the basic contours with a thin and fluid line. The young woman's face is softly and realistically modeled in chiaroscuro. Her left cheek and the tip of her nose are highlighted with white chalk, and chalk is broadly applied in the areas of the headdress and blouse. Johnson worked up these parts of the drawing heavily in chalk to bring greater emphasis to the smooth and beautiful face of the woman. Johnson's glowing character study of this young Bohemian peasant girl hints at his future dedication to depicting ethnic types in America.

William P. Babcock is best remembered for his close association with the French Barbizon painter Jean-François Millet. Babcock studied with Millet in the late 1840s and settled near him in the village of Barbizon. Relatively few of Babcock's works have been located, and the known oil paintings and drawings are generally small in size and feature allegorical or mythological subjects.

Babcock's charcoal-and-chalk drawing *Female Nude with Cupid*

was executed ca. 1866–77. In contrast with Eastman Johnson's more traditional technique, Babcock wields the charcoal with daring and brio. The work is dominated by assertive horizontal and diagonal lines that dart across the paper, suggesting a vital sense of movement. The dense and dark strokes of cross-hatching at the upper right convey a palpable sense of atmosphere. The firmness of Babcock's stroke almost caused the textured paper to tear in the areas of the woman's hair and the background landscape. The short curved lines that appear around the woman at the bottom of the composition verge on abstraction but are evidently meant to suggest the movement of water. Babcock's fleshy, Rubensesque treatment of the nude is in line with the work of other American allegorical painters of the mid-nineteenth century, such as Henry Peters Gray.

Winslow Homer's pencil drawing *Over the Garden Wall* of about 1879 also features a young woman in an outdoor setting. Homer's treatment of nature is, like Babcock's, free and suggestive, indicating the artist's emulation of the French Barbizon style. The drawing of the female figure, however, is hard and tight. This picture is a transitional work for Homer; it features the highly descriptive and factual drawing style found in his illustrations, which established his reputation, and the more naturalistic and expressive style that came to play a dominant role in his art in later years. In the 1860s and 1870s Homer favored pencil over watercolor, but surprisingly few of his pencil drawings from the period have been located.

Homer's pictures of the 1870s and early 1880s often featured fashionably dressed young women on holiday spending a few quiet moments alone in the countryside. As here, they regularly look away from the viewer and appear lost in thought. In his discussion of the Adler *Over the Garden Wall* for the catalogue of the 1977 showing of the collection at the Neuberger Museum, William H. Gerdts noted the figure's "longing" and "subdued state of repression," and recognized "the diminutive figure . . . hemmed in by the high wall over which she looks [as] a rustic counterpart to much nineteenth-century Germanic iconographic treatment of young women."[5]

Numerous other American artists of the period treated the theme of growing up and captured an undercurrent of anxiety. James Wells Champney, for example, frequently depicted the vexations of young women, as in *Indecision* of 1883.

Beginning in the 1870s young American artists traveled abroad regularly to receive academic training. Most often they went to Paris to attend classes, but on occasion they also sought instruction at academies in other European cities. Francis Davis Millet studied in Antwerp, where he developed a pictorial interest in history and costume. In later years he specialized in pictures that re-create the life and character of bygone times, particularly those of ancient civilizations, England, and America. Millet was undoubtedly inspired to undertake classical genre themes as a result of his admiration for the paintings of Sir Lawrence Alma-Tadema, whose paintings based on Greek and Roman themes were enormously popular in the 1870s and 1880s.

Millet's watercolor *Lacing the Sandal* of about 1883, a recent addition to the Adler collection, is related to the artist's first major classical genre painting, *Reading the Story of Oenone.* As art historian H. Barbara Weinberg has noted, the figure at the far right in the painting is a "first cousin" to that in the watercolor.[6] In *Lacing the*

Francis Davis Millet, *Reading the Story of Oenone*, 1883, oil on canvas. © The Detroit Institute of Arts, Detroit Museum of Art Purchase, Art Loan Fund and Popular Subscription Fund, 83.1

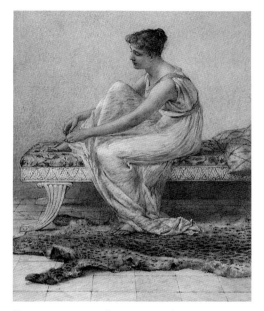

Francis Davis Millet, *Lacing the Sandal*, ca. 1883 (no. 46)

Sandal Millet worked with the precision of a miniaturist, tightly yet delicately rendering figure and setting. Particularly distinctive is the understated palette: the wall is pale gray, the floor is a cool shade of white, the divan is embroidered in blue and gold, and the young woman is dressed in a putty-colored robe through which her figure is subtly revealed. The watercolor's pale coloration brings to mind the pictures of the Englishman Albert Moore, one of the leading figures of the Aesthetic movement, which had a significant influence on American art in the early 1880s. *Lacing the Sandal* was shown at the 1883 annual exhibition of the American Water Color Society, where the art critic for *The Nation* found the picture graceful and beautiful but was disturbed by Millet's choice of values: "As regards the color values . . . the white-robed figure does not appear to us to tell as a white enough mass in relation to the background."[7]

William Merritt Chase was one of many American artists who traveled to Munich to study in the 1870s. There he attended the Munich Akademie and began to emulate the art of Wilhelm Leibl and his circle, who were greatly inspired by the broadly painted and darkly dramatic canvases of Gustave Courbet, Frans Hals, and Diego Velázquez. In later years Chase often traveled to Madrid to study the work of Velázquez at the Prado. In 1882 he went there in the company of his close friend Robert Frederick Blum. The art editor of *Century Magazine* had assured the artists that the magazine would publish an illustrated article featuring the drawings they produced. The article, titled "Street Life In Madrid," appeared seven years later, in November 1889.

A Countryman is one of five Spanish pictures by Chase illustrated in the issue.[8] In style the drawing reflects the artist's admiration for the works of both the seventeenth-century Spanish painter Velázquez and the late nineteenth-century French realist Edouard Manet. Chase vividly recorded his impression of the slightly stooped man dressed in native attire walking on a brightly lit street in Madrid. Initially Chase drew the entire figure in crayon. Next he worked with ink, carefully emphasizing the irregular silhouette of the figure and the texture and sheen of his clothing. Much of the figure is bathed in glaring sunlight. To indicate areas in deepest shadow, Chase used wet opaque wash. To create an overall harmonious impression, he applied transparent wash to areas of the upper portion of the figure. The artist worked in a similar tonalist manner when creating his later portrait drawing of his wife dressed as a Spanish girl, also in the Adler collection.

Robert Blum was one of the leading American followers of the nineteenth-century Spanish artist Mariano Fortuny. Following in Fortuny's footsteps, Blum often worked in pen and ink. In 1883 he had been a founding member of a short-lived organization dedicated to the medium. In 1884 the artist wrote an article for *The Studio* on the subject of pen-and-ink drawing in which he expressed his advocacy for the "legitimate" application of the medium and his admiration for those artists who understood its "distinct beauty," unique "rugged strength," and usefulness in making "bold assertions."[9] In light of the method Chase followed in *A Countryman*, it is interesting to note that Blum criticized artists who used wash in their pen-and-ink drawings for "touching up" the modeling of light and shadow.[10]

Study after "A Venetian Market" was executed in New York when Blum was asked by the American Water Color Society to pre-

pare a drawing related to his watercolor *A Venetian Market* (unlocated) for reproduction in the organization's 1889 exhibition catalogue.[11] Blum spent a considerable portion of the 1880s living and working in Venice, and, as in *A Venetian Market,* the beautiful young women of that city often served as the subject of his Italian pictures. Blum's technique in this drawing is expressive, rapid, improvisatory, and he used line in a personal, autographic manner. His lines are thin, varied in length, and broken. The vertical and horizontal patterns of lines surrounding the figure serve to suggest setting. Like Chase, Blum emphasized strong and dramatic contrasts of light and shadow. The woman's shawl and the area of shadow below her feet are dark in tonality, a result of the artist's vigorous application of straight- and cross-hatching.

Though best known today for his impressionist landscapes of the late 1880s and early 1890s, Theodore Robinson, during the course of his relatively brief career, adopted a variety of stylistic approaches. His *Reading (Study in Monochrome)* dates from the late 1880s, when the artist was living in France. The pencil-and-wash drawing is executed in the decorative mode that Robinson favored in his figure studies of the time. It is one of several monochromatic drawings featuring a seated young woman reading.

In *Reading (Study in Monochrome)* Robinson first drew the entire outline of the figure and chair thinly in pencil and rendered the folds and stitching on her dress. His line is subtle and flowing; it moves lightly and gracefully across the paper. The artist next applied transparent wash to areas of the chair and figure to convey delicately the tremulous play of light and shadow. By rendering only those aspects of form that he felt were most essential and by discriminatingly applying pencil and wash, Robinson cleverly simulated the fleeting thoughts of the beautiful young woman who has turned away from the book in her hand to daydream. In turn, Robinson's depiction of a mature and refined woman is an indication of the move by many later nineteenth-century American artists away from the girlish representations so common at mid-century.

Thomas W. Dewing's *Study (Lady with Flowers)* is one of the artist's many pastel drawings featuring beautiful women of slender elegance who appear to float in an ethereal dream world. Dewing's rarefied treatment of women has much in common with the English Pre-Raphaelites, the Aesthetic movement, and the art of James Abbott McNeill Whistler, who played a major role in the revival of interest in pastel in the United States in the late nineteenth century.

In *A Study (Lady with Flowers)* only the woman's head and left hand are fully drawn in pastel. Her face is pale and wistful, and her neck and figure are elongated. She seems to have been whispered upon the paper. Her willowy figure merges with the warm brown–toned paper, which acts both as a color and as a foundation tone. Dewing creates shimmering surface effects of light and texture by blurring outlines and applying long thin lines of pastel along the entire length of the figure. The tonal scheme consists of muted shades of white, blue, and black. Interestingly, Paul Cadmus's pencil drawing of an *Old Lady* in the Adler collection was inspired by his study of Dewing's art while attending a drawing class at the National Academy of Design.[12]

Mary Cassatt's *Study for "Young Women Picking Fruit"* is one of the artist's rare preparatory drawings of the 1890s. The study assisted Cassatt in completing her oil painting *Young Women Picking*

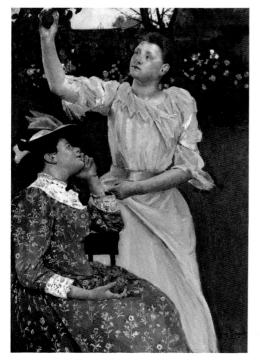

Mary Cassatt, *Young Women Picking Fruit,* 1891, oil on canvas. The Carnegie Museum of Art, Pittsburgh; Patrons Art Fund, 22.8

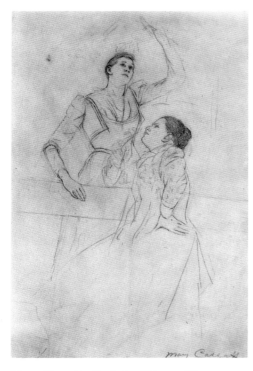

Mary Cassatt, *Study for "Young Women Picking Fruit,"* ca. 1892 (no. 15)

Fruit. Close examination of Cassatt's drawing leads to discoveries of areas of erasure and the artist's tentative rendering of the seated woman's right hand. The pose of the figures in the drawing is more graceful than that in the oil. In the finished painting Cassatt placed a hat upon the head of the seated woman and reversed the design. Stylistically, the drawing reflects the burgeoning influence of Japanese prints on Cassatt's art in her application of firmly drawn outlines, silhouetting of forms, emphasis on flatness, and limited depth in space.

Study for "Young Women Picking Fruit" and the finished painting in Pittsburgh relate thematically to the central section of the mural decoration, now lost, that Cassatt executed for the south tympanum of the Woman's Building at the 1893 World's Columbian Exposition in Chicago, in which women were represented picking the symbolic fruits of Knowledge and Science. The entire mural—fifty feet wide and twelve feet high—alluded to the strides made by contemporary women in educating themselves and providing for future generations.[13]

The Adler collection includes several ambitious portrait drawings dating from the late nineteenth and early twentieth centuries. Albert Edward Sterner's *My Wife in October 1897* is one of the most fascinating works in this group. Sterner began to execute portrait drawings in sanguine in 1896, and their exhibition shortly thereafter established his reputation, brought many commissions, and led to frequent gallery showings. According to Sterner's biographer, his drawings "did much to expose the popular American fallacy that a portrait of any particular consequence must be done in oils."[14]

My Wife in October 1897 is a tender but subtly disturbing sanguine portrait. Marie Sterner's attire is ruffled and she looks to her right with a solemn and apprehensive expression. The right side of her face is hidden in shadow, and strands of hair fall toward her forehead and eye. With the sharp point of his red chalk Sterner nervously and somewhat fussily rendered the hair and left side of his wife's face. On the top edge of her nose and right side of her face he worked against the grain of his textured paper to create coarse surface effects. When drawing the scarf and blouse, Sterner's chalk seems to move with a life of its own; lines undulate, waver, and flutter. Sterner often sought to capture a note or undercurrent of anxiety in his drawings by portraying his subjects in a state of discomposure. His interest in representing disquieting psychological effects developed as a result of his study of European Symbolist art.

After 1906 John Singer Sargent declined most portrait commissions for oils. Now he turned to the medium of charcoal to satisfy the demands of aristocratic patrons, for whom a Sargent portrait represented a symbol of social status.[15] Between 1907 and 1925 Sargent executed approximately six hundred portraits in this medium. In style they range from the simple and broadly sketched to the elaborate and highly finished. Sargent's large charcoal portrait of Mrs. Claude Beddington was executed in London in March 1914. Mrs. Beddington (born Ethel Mulock) was a society hostess of Irish extraction and the wife of the Abdullah cigarette magnate Claude Beddington.

Mrs. Beddington's autobiography, *All That I Have Met,* includes a rare personal account of the experience of sitting for a Sargent

charcoal portrait. Mrs. Beddington prepared for the occasion by wearing a classically draped velvet evening dress, but Sargent asked his sitter to abandon the idea of being drawn in this attire. He requested that she don a pearl necklace and commented that "the mere fact of your wearing a necklace indicates a fully clothed condition."[16] As he proceeded with the two-and-three-quarter-hour sitting, Sargent encouraged her to offer criticism. Upon asking Mrs. Beddington if she would like her mouth to appear open or closed, she remarked, "Shut, for the love of goodness, because my friends all declare I never stop talking."[17] Mrs. Beddington noted that Sargent "would dash on some lines with the charcoal, rub out with the French roll [a stump for removing charcoal from paper], occasionally retreat to the far end of the studio and then almost run at the portrait."[18]

Sargent's portrait of Mrs. Beddington is highly finished and formal in character. Elegant and dignified, it perfectly reflects the ebullience, grandeur, and class of his sitter. Generally, the artist's charcoal likenesses of women tend to be more stylized than those of men. Sargent elongated the sitter's neck in order to increase the distinction of her head and lift it higher above her shoulders. He defined Mrs. Beddington's facial features softly in outline, emphasizing her strong chin, full sensual lips, and strong, alert eyes. The right side of her face and her hair are sharply outlined in black and stand out forcefully against the white paper. The artist applied charcoal more vigorously and uninhibitedly when modeling the sitter's skin tones and drawing areas in shadow. Sargent used his French roll to create the bright highlights on her forehead, in the pupils of her eyes, and on her nose.

Sargent's portrait style had a major influence on the artists of Boston at the beginning of the twentieth century, and his charcoal likenesses may possibly have inspired Joseph R. De Camp to try his hand at drawing large and ambitious portraits of the citizens of his home city.[19] In subject and style De Camp's portrait of the promising young actress Peggy Wood is consistent with the type of portrait synonymous with Sargent and the Boston School: stylish and intelligent, elegant and accomplished. It was executed about 1910, not long after the artist turned to portraiture as a means of supporting his family after the tragic destruction of his studio by fire. As always, De Camp draws with academic correctness. Tone is balanced against tone. The soft, tremulous play of light and shadow is rendered exquisitely. The color is sober but subtle. The portrait is mostly drawn in pencil and black pastel, but white and blue pastel are used with utmost discrimination by De Camp to highlight the sitter's eyes and a portion of her scarf. The artist lightly animated the edges of the sitter's finely drawn hair through his judicious smudging of the black pastel.

Lilian Westcott Hale was also affiliated with the Boston School at the turn of the century. She studied with Edmund C. Tarbell at the School of the Museum of Fine Arts, Boston, and married Philip Leslie Hale, one of the city's leading artists. She is best known for her charcoal portrait drawings. During her lifetime, these were highly regarded for their painstaking craftsmanship, great subtlety, and unusual design.[20]

The Adlers' likeness of Hale's mother, Mrs. E. G. Westcott, whom she depicted a number of times in charcoal, is drawn with great precision and entirely with thin, straight vertical strokes. Hale

worked with charcoal sharpened to a point constantly kept keen with a razor blade. The long, gracefully arranged parallel lines of dark charcoal that the artist placed around the subject's head and on her upper body serve elegantly to frame and emphasize the sitter's lightly drawn face.

William McGregor Paxton was a prominent figure in Boston art circles well into the twentieth century. He was a staunch traditionalist and an avatar for the ideals of the Boston School. His aesthetic was highly conservative and went hand in hand with his reverence for the work of the Old Masters, belief in the importance of long and rigorous artistic training, and utmost respect for the beautiful and the harmonious. Paxton was rarely satisfied with the results of his drawings. They were, however, greatly admired by Sargent and De Camp. "He is something," De Camp remarked, "that only happens once in a while and there may not be another such for another hundred years; a real draughtsman."[21]

Paxton's charcoal drawing *After the Bath* was executed in the last decade of the artist's career when he frequently treated the subject of the female nude in an interior.[22] His paintings of the nude were awarded the top prize at the Corcoran Gallery of Art's biennial exhibitions of 1930 and 1938. Paxton was a great admirer of the art of Jean-Auguste-Dominique Ingres, as evidenced in *After the Bath*, which was influenced by the nineteenth-century French artist's bathing scenes featuring voluptuous female nudes and his neoclassical canon of beauty and proportion. Paxton's work is drawn mostly with straight lines; areas of parallel- and cross-hatching predominate. The figure's sinuous and supple form is marvelously accentuated by the interior's curvilinear-shaped objects and partial reflection in the background mirror. Rather than draw the reflection of the towel in the mirror, Paxton cleverly chose to leave this part untouched by charcoal and so gave the white paper a role in the composition. Similarly, the area at the upper right is left undrawn to indicate the bright sunlight streaming in through the window. Using the method of selective focus (which he termed "binocular vision"), Paxton sharply drew the central area of the composition and slightly blurred the periphery.

At the turn of the century in New York, Robert Henri and his circle created art that was a far cry from the idealism, refinement, and meticulous craftsmanship of the work of the Boston School. Influenced strongly by French Realism and the baroque art of Spain and Holland, Henri, George Bellows, John Sloan, William Glackens, Everett Shinn, and George Luks created art that was raw, expressive, vital, and socially relevant. This group of young artists, who consciously broke with the genteel and academic tradition, came to be known as the Ashcan School.

Sloan is represented in the Adler collection by two drawings dating a decade apart and revealing the development and radical change in his aesthetic. *The Couple* was executed in 1894 on assignment for the *Philadelphia Inquirer*.[23] It is one of several drawings by Sloan depicting fashionable and idealized young women in romantic situations, a theme that initially established his reputation as an illustrator.[24] In style and technique the picture reflects the influence of Art Nouveau and Sloan's recent exposure to Beisen Kubota's Japanese brush technique at the Philadelphia School of Design for Women and close personal study of Kubota's sketchbooks of brush-and-ink drawings. In *The Couple* Sloan worked with a half-dry

brush, emphasizing heavy lines, solid masses of black, two-dimensional decorative patterns, large areas of contrasting colors, bold whiplash outlines, and silhouetted forms.

He Was Quickly Placed in His Carriage was drawn in 1904 at the time of Sloan's settlement in New York. It is one of more than one hundred drawings that the artist prepared for publication in a deluxe American edition of the writings of the early nineteenth-century French humorist Charles Paul de Kock.[25] It is also one of numerous drawings executed for the assignment that feature well-to-do people in awkwardly comical situations. In comparison to this drawing, *The Couple* seems affected, artificial, and overly decorative. In the later work Sloan broadly sketched his subject, employing a full range of tonal values and emphasizing texture. Direct and forthright, the drawing is far from sentimental. The figures, which appear natural and true to life, are caught in action, standing, turning, lifting arms. Facial expressions are equally varied and expressive. Sloan rarely used charcoal before the twentieth century, but after he abandoned the tight drawing style and flat decorative compositional design of his work of the 1890s, it became one of his favorite drawing materials.

Sloan's friend and colleague William Glackens also was active as an illustrator. In 1896 Glackens left Philadelphia for New York seeking better opportunities. From 1902 to 1912 he illustrated numerous stories dealing with the lives of the urban working class for the *Saturday Evening Post*. *Gloriana! Come on, Gloriana!* appeared in the *Post* in 1907 as an illustration for a story by Jacques Futrelle about a man of modest means who bets his life's savings on the racehorse Gloriana.[26] First Glackens drew the composition faintly in blue pencil. Then he heavily outlined figures in crayon and vigorously modeled the forms with parallel hatching to instill the subject with life and animation. Glackens's technique is forceful and spirited. He was a master at composing groups of figures in interaction and depicting comic misadventure.

Early in his career Everett Shinn worked principally in pastel. His drawings in the medium were well received in several one-man exhibitions in New York at the turn of the century. *Reclining Female* dates from 1904 and features a young show girl napping during a break from entertaining. She is so fatigued from work that she must catch a nap when a moment is available. Though his subject lies dormant, Shinn's treatment is far from static. His line is restless, animated, and full of verve. Pastel and charcoal are applied with alternately long and jagged strokes. The coloring is soft and understated but deeply evocative, with the woman's skin and dress in pink tones and her clothing accented with touches of green, yellow, and orange. The finely textured paper is light blue. Shinn's admiration for the art of Edgar Degas is reflected in his use of pastel and the representation of a performer at an unguarded moment. *Reclining Female* is far from Dewing's contemporary pastels of aloof and mysterious women. For Shinn every drawing was based on the study and observation of real life.

Joseph Stella's sympathetic drawings of urban immigrants dating from the first decade of the twentieth century are allied in spirit with the works of the Ashcan School. During this period Stella worked as an illustrator for *The Survey*, a publication that exposed the poor working conditions of immigrant mine workers through sensational exposés and striking pictures. *The Puddler* is one of the

most powerful drawings that Stella executed on his 1908 assignment for *The Survey* to observe the arduous working conditions at the steel mills of Pittsburgh. The drawing, rendered with the seriousness of purpose of the Old Masters, owes its inspiration to Stella's study of the art of the fifteenth-century Italian painters Masaccio and Andrea Mantegna.

To achieve the maximum graphic impact Stella placed the puddler in silhouette near the center of the composition and emphasized the irregular contours and massive frame of his torso. The worker is drawn stirring pig iron in a furnace in the process of converting it to steel. His face is turned away and he remains anonymous. Pastel is applied heavily, the resulting textures serving to emphasize the strain on his muscles. The bright light of the furnace dramatically illuminates his arm and casts a ghostly radiance over his back and legs. The somber color scheme of blue, brown, and black evokes the bleakness and tragedy of those whom Stella later referred to as "exiles from beauty."[27] Stella's striking drawing of the anonymous steelworker communicates the age-old axiom that man will find the strength to survive. When *The Puddler* was reproduced in color as the frontispiece for the 2 April 1909 issue of *The Survey*, the caption below the drawing stated, simply, "Strong backs go into steel."

In the 1920s a new generation of urban realists appeared on the American art scene. Among this group were Kenneth Hayes Miller, Reginald Marsh, Edward Lanning, and Isabel Bishop. All of these artists at one time had their studios in the vicinity of Manhattan's Union Square and came to be known as members of the Fourteenth Street School. Bishop kept her studio in the area for more than fifty years. In the 1920s she studied with Miller and Marsh at the Art Students League. Bishop's art never took on Marsh's satiric edge and baroque voluptuousness. Remaining Miller's disciple, she stressed sculptural solidity and approached her subjects with classical restraint.

Two Girls, Study was created in 1934 on one of Bishop's frequent sketching excursions around Union Square Park. Like many of her genre drawings, the picture features young working-class women on their lunch hour. As one writer has noted, the women who worked as salesclerks and secretaries in the area in the 1920s and 1930s were a "new generation of strong and robust middle-class women freely moving about the city unhampered by the conventions which restrained their mothers."[28]

Two Girls, Study was carefully created layer by layer. First Bishop covered the paper with a light gray wash, which helps to convey the overall impression of light and atmosphere. Next Bishop's pen fluidly and expressively indicated forms, planes, and shadows and instilled the figures with a sense of volume and potential mobility. Then, to further the illusion of three-dimensionality, the artist applied dark gray wash to the figure on the right and placed a shadow beside the figure on the left. As Bishop later related, what interested her was "the play between the form of the clothes and the form of the body."[29]

The Adler collection contains early twentieth-century modernist figurative drawings by Elie Nadelman, Hugo Robus, John Storrs, and others. In their highly stylized pictures, Nadelman and Robus abstracted the basic form and rhythm of the human figure and emphasized curves and countercurves. Each artist aimed to create

works that are serene and beautiful, expressively revealing the essense of human form.

From about 1904 to 1910 Nadelman created a series of analytical pen-and-ink drawings of the human figure based on naturalistic observation. The series, executed in Paris, was eventually titled "Researches into Harmonious Relationships of Forms and Volumes." The drawings reflect the influence of Nadelman's study of Greek classical and Hellenistic sculpture and Art Nouveau. While working on his drawings, Nadelman was visited in his studio by Pablo Picasso. In later years the American proclaimed that his series had a strong influence on the Spaniard's development of Analytical Cubism.

In a study of the technical variations among Nadelman's series, art historian Athena T. Spear identified eight different styles.[30] *Seated Figure* corresponds to style G, dating from 1908–10, which features intersecting curves, arcs, and sinuous lines, both with and (as here) without shading. The female form is reduced to curved lines, which indicate pose and gesture and the inclination of the head and emphasize volume and plasticity. The artist's line is calligraphic and flowing and organic in conception. It snaps nervously across the paper and asserts a sense of tension and balance. In 1910 Nadelman wrote: "I employ no other line than the curve, which possesses freshness and force. I compose these curves so as to bring them in accord or in opposition to one another. In that way I obtain the life of form, i.e. Harmony."[31] Nadelman's drawing looks ahead to John Sennhauser's later abstract drawings in ink in which the artist worked completely in line, as in the untitled ink drawing of 1941 in the Adler collection.

Hugo Robus's *Beach Scene* is one of only approximately fifty known drawings by the artist. Robus appears to have destroyed many of his works after abandoning painting in 1920 to devote his entire attention to sculpture, and he rarely drew after that. The Adlers' pencil drawing dates from about 1918, when his pictures regularly were composed of fragmented people in a crowd.[32] *Beach Scene* apparently served as a study for a painting in oil. Following the example of Cubism, Robus organized his composition into a linear grid, treated figures from multiple viewpoints, and simplified and abstracted human forms and landscape elements by rendering them only partially in contour and leaving out parts of their silhouette. Chevron-shaped force lines common to Futurism appear throughout, serving to unify and animate the composition. Robus's black pencil line weaves rhythmically across the off-white paper, and figures seem to float in space. Working with the side of his pencil to indicate shading on the receding planes of figures, Robus subtly implied a feeling of depth and volume. Robus's abstract sculptures of the 1920s would employ the drawing's prismatic design.

John Storrs drew continuously throughout his life, but, like Nadelman and Robus, was chiefly active as a sculptor. He favored working in charcoal and silverpoint, and his works on paper were strongly influenced by Art Deco. Though best known for his non-representational sculptures, beginning in the 1920s Storrs also actively accepted commissions to execute portrait busts.

In *Female Head* Storrs was principally interested in working out the relationship of edges and surfaces. To help accomplish this aim he placed the model's head on a slight diagonal so that her form

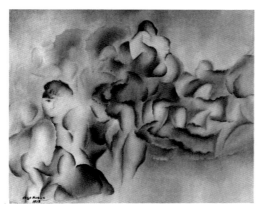

Hugo Robus, *Untitled*, 1918, oil on canvas. Harriette and Noel Levine, New York

Hugo Robus, *Beach Scene*, ca. 1918 (no. 53)

would stand out in silhouette. The artist used a minimum of charcoal lines to describe the shape of her head and neck but more thoroughly delineated her facial features and darkly rendered her eyes and top lip to make them appear to come forward in space. Finally, he instilled the figure with a sense of roundness and volume by strengthening the contour line on the right side of her face and chin. Storrs's line is continuously simple and flowing. His drawings are distinguished by their refinement, purity, and ornamental gracefulness. The fact that his women look like goddesses is a reflection of his high regard for classical art and the beautiful.

Emil Bisttram is represented in the Adler collection by three drawings, all of which reflect his dual interest in representation and pure abstraction. *Pearls and Things and Palm Beach* was created in 1925 for the cover of a promotional pamphlet advertising the thirty-fifth anniversary of Greenleaf & Crosby Company, which operated a jewelry store in the Breakers Hotel in Palm Beach, Florida. By this time Bisttram had established a major reputation as an illustrator and was working on a free-lance basis in New York.

Pearls and Things and Palm Beach reflects Bisttram's devotion to the principles of Dynamic Symmetry. This mathematical system of composition developed by Jay Hambridge was used by many American artists of the time in order to establish a harmonious geometrical framework for their work.[33] Dynamic Symmetry, Bisttram believed, released artistic powers, and in *Pearls and Things and Palm Beach* the artist vigorously applied what Hambridge termed "root rectangles" and "whirling squares." The composition is divided into rectangles painted in scintillating shades of pink, green, silver, purple, yellow, and brown. Lines move broadly across and down the picture plane.

In 1938 Bisttram founded the Transcendental Painting Group in Taos, New Mexico, in the wake of the formation of the American Abstract Artists organization in New York. Bisttram's group created nonobjective pictures following the principles formulated by the early pioneers of abstract art, including Wassily Kandinsky, František Kupka, Robert Delaunay, and Piet Mondrian. Members of the Transcendental Painting Group sought to represent the transcendent qualities inherent in existence, the ways in which the "life-force" expresses itself in everyday life, and the rhythms created by life's unfolding cycles, such as growth and self-realization. They felt that art must transcend the physical and material world and act as a vital spiritualizing force.

Time Cycle #1 is the first of a series of large, nonobjective charcoal drawings by Bisttram dealing with the transcendent notion of time and space. According to Bisttram, the overall design of *Time Cycle #1* was meant to suggest "a pendulum in the shape of a scythe, [the grim] reaper swinging in eternal space." Bisttram also remarked that the entire Time Cycle series was "the result of meditation on time and space, the two variables of all existential reality," in which he saw "the lines of force or energy permeating space, . . . passing through the . . . organizing centers of the body" and assuming "the geometrical shapes of our world before matter condenses or crystallizes them."[34]

Time Cycle #1 was drawn with the aid of a ruler and compass, creating a clean, sharp, and readily comprehensible geometric design. Bisttram at this time looked upon design as a means both to instill order and dynamically relate a chain of thoughts and feelings

about existential questions, here dealing with the theme of death, the end of the cycle of life. He relied upon Dynamic Symmetry's "root rectangles," "whirling squares," and "whorling spirals" to help him create this harmonious and animated composition. The picture additionally reflects his belief that an artist must "reveal the hidden beauty and transcendent mystery which is the core of nature."[35]

Louis Lozowick's *Machine Ornament #4* is also part of a larger series. Inspired by El Lissitzky's Proun drawings, Lozowick set out in the mid-1920s to develop a contemporary style of ornamentation based on his observations of the American industrial landscape.[36] He believed that the dominant trend in America in the early twentieth century was "towards order and organization which [found their] outward sign and symbol in the rigid geometry of the American city; particularly in the verticals of its smoke stacks, in the parallels of its car tracks, the squares of the streets, the cubes of its factories, the arc of its bridges, the cylinders of its gas tanks."[37]

During the late 1920s many of Lozowick's machine-ornament drawings were published in the Socialist periodical *New Masses,* where they served to underline the important role that industrialization plays in a workers' society. From our contemporary perspective, the drawings in the series transcend questions of politics or social theories. Above all else, form and composition were primary to Lozowick's conception. His machine-ornament drawings are among the most beautiful, powerful, and optimistic pictures dealing with the machine image in American art.

Machine Ornament #4 is meticulously drawn. The edges are crisp and clean. Ink is densely but smoothly applied to suggest a feeling of weight and mass. Lozowick's approach was synthetic; he formed the image from parts of a variety of machines chosen completely for their formal character and joined them together to form a new whole. Lozowick aligned the composite form on a receding diagonal to create the illusion that it is floating in space. The image is arranged asymmetrically but in perfect balance. The design is linear, compact, and angular, elegantly reflecting the precision, economy, and order of modern technological construction.

In recent years the number of still-life drawings and watercolors in the Adler collection has grown enormously. The Adlers have developed a special interest in the work of American nineteenth-century artists who were indebted to the influence of the English Pre-Raphaelites. This includes the work of Fidelia Bridges and Ellen Thayer Fisher, two leading women still-life specialists who worked regularly in watercolor. Bridges is represented in the Adler collection by *Flowering Vine,* ca. 1870–71, and Fisher by *The Orange Bloom and the Myrtle Bay,* 1885. There are also several unusual and rare works on paper by notable American still-life painters of the period. These include one of William M. Harnett's few known drawings, possibly his only treatment of a floral subject. *Iris* dates from early in the artist's career when he was working as an engraver for a jewelry firm in New York. The American Pre-Raphaelite still-life specialist Francesca Alexander is represented by two rare early portraits. These ink-and-pencil drawings are rendered with the exacting line and naïve vision that later attracted the interest and enthusiasm of the English writer John Ruskin. The Connecticut trompe l'oeil painter John Haberle is also represented by a portrait. His *Head of a Man* was executed in 1894, after the physical demands

of Haberle's meticulous style of still-life painting had affected his eyesight, leading him to turn to the human figure.

The Adler collection also includes twentieth-century still lifes by Jan Matulka, Walter Murch, Lucas Samaras, and George Ault. Ault's *Little White Flower* is perhaps the most beautiful and fascinating still life in the collection. This picture was executed in 1939, during a difficult period of Ault's life and career. He had broken with the Downtown Gallery in 1934 after the gallery owner, Edith Halpert, had insisted that he continue to paint the Precisionist cityscapes that had established his reputation. Not long after breaking with Halpert, Ault moved permanently to Woodstock, New York. There he worked in relative isolation and in desperate poverty. He became increasingly dependent on his wife, Louise, for emotional support. The move helped renew his appreciation for nature, and he often painted small watercolor and gouache still lifes of floral subjects as Christmas gifts for people he worked with or who worked for him, as well as for his landlady and relatives who helped him out financially.

Little White Flower was given by Ault to his wife as a birthday present and as a symbolic remembrance of a walk they had taken together in the woods where they had come upon an unusual six-pointed anemone. Upon arriving home after the walk, Ault found a five-pointed wood anemone near the house, placed it in a small clear glass, and painted this watercolor and gouache.[38] The picture relates to the Precisionist aesthetic in its hard-edged manner of drawing and reductive geometry. Color is applied flatly, and the surface has a silky texture. The palette of red, white, and shades of black harks back to that of his earlier nocturnal cityscapes. The dim overall lighting heightens the solemnity of the scene. Like much of the artist's oeuvre, the picture is marked by a bleak and melancholy mood. In 1941 Ault discontinued working in watercolor and gouache, feeling that he had time only for oil.

There are three watercolor landscapes in the Adler collection. Childe Hassam's *San Pietro, Venice* dates from the artist's first trip abroad, when he was still under the influence of the early nineteenth-century English watercolorists, particularly J. M. W. Turner.

Oscar Bluemner is represented by two of his most significant watercolor landscapes of the 1920s and an earlier crayon drawing. The German-born artist led a deeply private and solitary life, mostly in New Jersey and Massachusetts. He wrote voluminously in notebooks about his theories, detailing the symbolic and emotional importance of various colors, lines, and shapes, which he saw as taking on human personalities and characteristics. Bluemner applied watercolor in a resonant and saturated manner, which gives his works in the medium the appearance of oils.

Venus is Bluemner's tone poem to the goddess of love and the mysterious procreative forces underlying nature. The picture represents the symbolic mating of male and female. The red phallic structures at far left are meant to indicate the male, and the round, hilly earth and curving trees represent the female. Layers of transparent watercolor are evenly washed over one another to produce a dense and expressive effect. The resulting surface is smooth and sensuous; one critic of the period likened the surface of Bluemner's watercolors to "fine procelain."[39] The artist chose to outline most of the forms in a thick black contour line, which serves to separate

the rich and various colors into distinct areas. The entire landscape seems to sway in a gentle breeze.

Bluemner painted *November Moon* in 1927. At the center of the picture the moon appears as a large ovoid shape. Bluemner did not draw this form, simply utilizing the whiteness of the paper. The shapes surrounding the moon overlap and seem to dissolve in air. In other areas of the composition red is played off against complementary blues and greens. In this work Bluemner fortified the medium with casein binder and waterproofed each layer of color with formaldehyde to give tonal amplitude. Bluemner's pictures are paeans to nature and the human spirit. Mystical and romantic, they are meant to be understood through the senses. Bluemner often remarked that it was not important to "insist on 'understanding' what seems strange. When you 'FEEL' colors, you will understand the 'Why' of their forms. It is so simple."[40]

As we have seen, many of the pictures in the Adler collection add significantly to our knowledge of the history and development of American drawings and watercolors. The collection chronicles the work of well- and lesser-known artists of the past, providing a survey of the achievements of American draftsmen and a superlative model for collecting in this area of nineteenth- and early twentieth-century art. When Herbert Adler began to collect in the mid-1960s he was one of the few in this country who gave his attention completely to American works on paper. At the time there were also few publications dealing with the subject in depth. There are now growing numbers of collectors and studies. It is hoped that through the exhibition and this accompanying publication both the Adlers and the Norton Gallery of Art will further appreciation of American drawings and watercolors and encourage scholarship in this important area of American art. The Adler collection will certainly continue to evolve; even as this essay goes to press the Adlers have acquired a major early drawing by Daniel Ridgway Knight titled *Study for "The Harvest."*

NOTES

1. *American Drawings and Watercolors from the Collection of Susan and Herbert Adler,* essay by William H. Gerdts, catalogue entries by Bruce Weber (Purchase: Neuberger Museum, State University of New York, 1977).

2. Kensett's drawings were the subject of a relatively recent exhibition; see John Paul Driscoll, *John F. Kensett Drawings* (University Park: Museum of Art, Pennsylvania State University, 1978).

3. John Paul Driscoll, "From Burin to Brush: The Development of a Painter," in John Paul Driscoll and John K. Howat, *John Frederick Kensett: An American Master* (Worcester, Mass.: Worcester Art Museum, 1985), p. 58.

4. Patricia Hills to Bruce Weber, 20 June 1988.

5. William H. Gerdts, "The Adler Collection," in *American Drawings and Watercolors from the Collection of Susan and Herbert Adler,* p. vi.

6. H. Barbara Weinberg to Herbert Adler, 16 June 1988. Weinberg is the author of "The Career of Francis Davis Millet," *Archives of American Art Journal* 17, no. 1 (1977), pp. 2–18.

7. "The Watercolor Exhibition," *The Nation* 36 (15 February 1883), p. 157.

8. Susan N. Carter, "Street Life in Madrid," *Century Magazine* 29 (November 1889), p. 35.

9. Robert Frederick Blum, "Technical Methods of American Artists: VI. Pen and Ink Drawing," *The Studio* 3 (3 May 1884), pp. 173–75.

10. Ibid., p. 174.

11. See Bruce Weber, "Robert Frederick Blum (1857–1903) and His Milieu," Ph.D. dissertation, Graduate School of the City University of New York, 1985, vol. 1, p. 318.

12. Paul Cadmus to Herbert Adler, 1 February 1972.

13. For a discussion of *Study for "Young Women Picking Fruit"* and the mural commission in general, see Nancy Mowll Mathews, *Mary Cassatt* (New York: Harry N. Abrams, 1987), pp. 84–91.

14. Ralph Flint, *Albert Sterner: His Life and His Art* (New York: Payson & Clarke, 1927), p. 26.

15. Sargent worked with charcoal from early in his career for studies for paintings. Beginning in the mid-1870s he ocassionally executed portraits of friends in the medium. For a recent study of Sargent's drawings, see Patricia Hills, "A Portfolio of Drawings," in *John Singer Sargent* (New York: Whitney Musueum of American Art, 1986), pp. 251–74.

16. Mrs. Claude Beddington, *All That I Have Met* (London: Cassel and Company, 1929), p. 152.

17. Ibid., p. 153.

18. Ibid., p. 154.

19. For a recent study of the Boston School, see Trevor Fairbrother, *The Bostonians: Painters of an Elegant Age, 1870–1930* (Boston: Museum of Fine Arts, 1986).

20. See, for example, Rose V. S. Berry, "Lilian Westcott Hale—Her Art," *American Magazine of Art* 18, no. 2 (February 1927), pp. 58–70.

21. Quoted in Ellen Wardwell Lee, *William McGregor Paxton 1861–1941 (Member of the National Academy)* (Indianapolis, Ind.: Indianapolis Museum of Art, 1978), p. 54.

22. A nearly identical treatment of the subject in pastel is in the collection of the Whistler Museum and Parker Gallery, Lowell, Massachusetts.

23. The work illustrates H. E. Clark's story "Sentence of Death" and appeared on the front page of the Sunday Supplement of the *Philadelphia Inquirer* for 22 July 1894.

24. For a discussion of Sloan's illustrations of this period, see F. Penn, "Newspaper Artists—John Sloan," *Inland Printer* 14 (October 1894), p. 50.

25. *He Was Quickly Placed in His Carriage* appeared as an illustration in Charles Paul de Kock, *Andŕe the Savoyard* (New York: F. J. Quinby, 1904), vol. 2, opp. p. 122.

26. Jacques Futrelle, "Enter the Duke (Batty Logan Stakes a Rival and Plays at Providence)," *Saturday Evening Post*, 17 August 1907, pp. 8–10, 23, illus. p. 9.

27. Joseph Stella, "Discovery of America: Autobiographical Notes," *Artnews* 59 (November 1960), p. 41.

28. Bruce St. John, Foreword to *Isabel Bishop: The Affectionate Eye* (Los Angeles: Laband Art Gallery, Loyola Marymount University, 1985), p. 6.

29. Isabel Bishop, Statement on Drawings in *Isabel Bishop: The Affectionate Eye*, p. 15.

30. Athena T. Spear, "The Multiple Styles of Elie Nadelman: Drawings and Figure Sculptures ca. 1905–1912," *Allen Memorial Art Museum Bulletin* 31 (1973–74), pp. 34–58.

31. Elie Nadelman, Statement on Drawings in *Camera Work*, no. 32 (October 1910), p. 41.

32. Roberta K. Tarbell to Herbert Adler, 26 April 1978. Tarbell is the author of "Hugo Robus' Pictorial Works," *Arts Magazine* 54 (March 1980), pp. 136–40.

33. Jay Hambridge's ideas circulated widely through the publication of his books *Dynamic Symmetry* (New Haven: Yale University Press, 1919) and *Dynamic Symmetry in Composition as Used by the Artist* (New Haven: Yale University Press, 1923) and the magazine *Diagonal*.

34. Emil Bisttram, "The New Vision in Art," *Tomorrow* 1, no. 1 (September 1941), pp. 37–38.

35. Bisttram quoted in Robert C. Hay, "Dane Rudhyar and the Transcendental Painting Group of New Mexico from 1938–1941," M.A. thesis, Michigan State University, 1981, p. 209.

36. Lozowick saw Lissitzky as "communicating to his work the spirit of constructiveness and organization reigning in the life around him" (Louis Lozowick, *Modern Russian Art* [New York, 1929], p. 35).

37. Louis Lozowick, "The Americanization of Art," in *Machine-Age Exposition* (New York: The Little Review, 1927), unpaginated.

38. *Little White Flower* is discussed in Louise Ault, *Artist in Woodstock* (Philadelphia: Dorrance & Company, 1978), pp. 27, 51. For a general discussion of Ault's later still lifes, see the George C. Ault Papers, Archives of American Art, Washington, D.C., roll D247 frame 943; roll 1927, frame 781.

39. "Art: Exhibitions of the Week (Emotion Controlled)," *New York Times*, 23 November 1924, sec. 8, p. 12.

40. Oscar Bluemner, Introduction to *Oscar Florianus Bluemner* (Minneapolis: University Gallery, University of Minnesota, 1939), unpaginated.

BRETT I. MILLER

Catalogue of the Exhibition

Dimensions, which indicate sight size, are given in inches (and centimeters), height × width.

Locations of signatures, dates, and inscriptions are indicated by abbreviation: l.r. (lower right), l.l. (lower left), u.r. (upper right), u.l. (upper left), l.c. (lower center), u.c. (upper center), c.l. (center left), and c.r. (center right).

In the exhibition histories and selected references, the entry Neuberger Museum, 1977, refers to the exhibition and catalogue *American Drawings and Watercolors from the Collection of Susan and Herbert Adler*, Neuberger Museum, State University of New York at Purchase, 1977.

References are selected. Only where the specific work in the Adler Collection is discussed is the publication cited. Publications in which the work in the Adler Collection is reproduced but not discussed are not cited.

The Appendix following the catalogue documents works not included in the exhibition.

1 FRANCESCA ALEXANDER
1837–1917

Catherine and Cornelia Cruger

1858
Ink and pencil
10⅜ x 7½ (26.3 x 19.0)
Inscribed l.l. *Catherine C. Cruger*; inscribed l.r. *Cornelia Cruger*;
dated l.l. *June 1st, 1858*

PROVENANCE	Constance Grosvenor Alexander (the artist's cousin) Helen Temple Cook Pine Manor Junior College, Chestnut Hill, Massachusetts Goodspeeds Book Shop, Boston Childs Gallery, Boston Mr. and Mrs. Stuart Feld, New York Adler Collection, 1982
EXHIBITED	*Francesca Alexander*, Childs Gallery, Boston, 1977, no. 1.

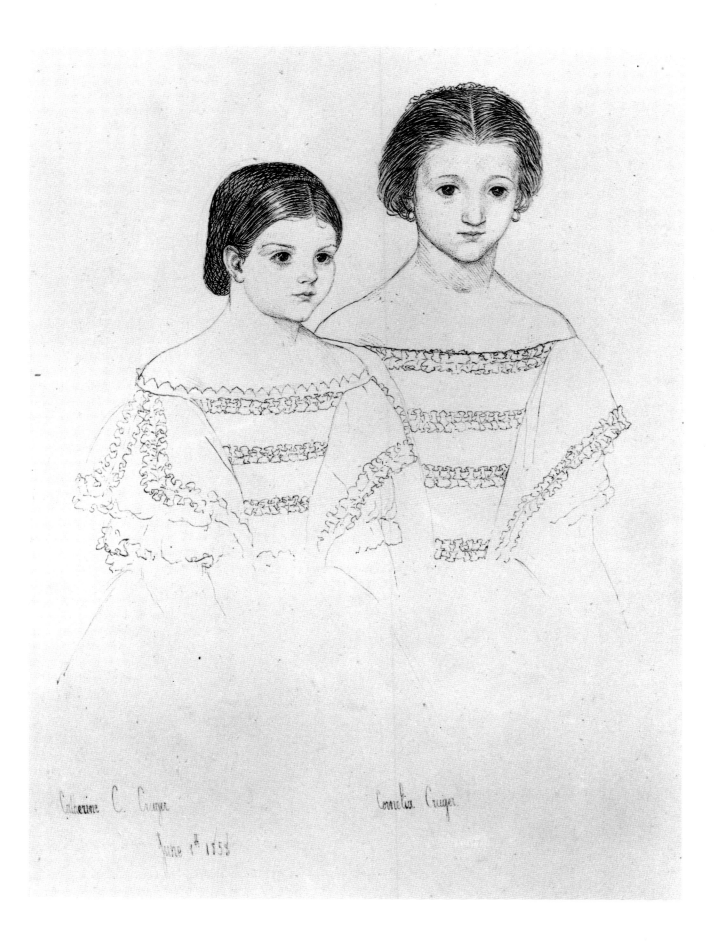

Catherine C. Cruger Cornelia Cruger

June 1st 1851

2 GEORGE AULT
1891–1948

Little White Flower

1939
Watercolor and gouache
8½ x 6½ (21.6 x 16.5)
Signed and dated l.r. *G. C. Ault '39*

PROVENANCE	Louise Ault (the artist's wife) Dr. Noble Endicott Richard York Gallery, New York Adler Collection, 1983
EXHIBITED	*The Natural Image*, Richard York Gallery, New York, 1982, no. 1. *George Ault*, Whitney Museum of American Art, New York, 1988.
REFERENCES	George C. Ault Papers, Archives of American Art, Washington, D.C., roll 1927, frame 781; roll D247, frame 943. Louise Ault, *Artist in Woodstock* (Philadelphia: Dorrance & Company, 1978), pp. 27, 51.

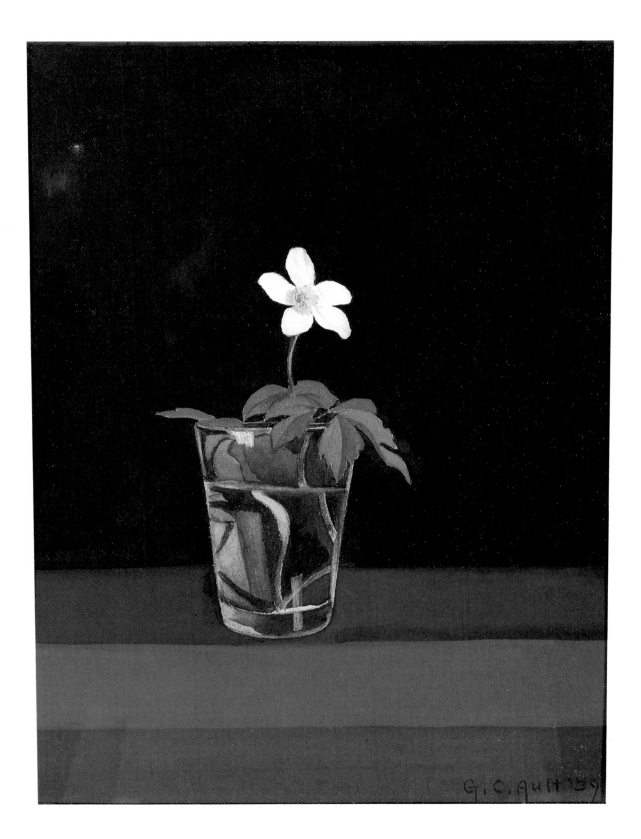

3 WILLIAM P. BABCOCK
1826–1899

Female Nude with Cupid

ca. 1866–77
Charcoal and chalk
12 x 9 (30.5 x 22.9)

❖

PROVENANCE | Estate of the artist
By descent in the artist's family until 1979
James Bakker, Boston
Rifkin-Young Fine Arts, New York
Adler Collection, 1984

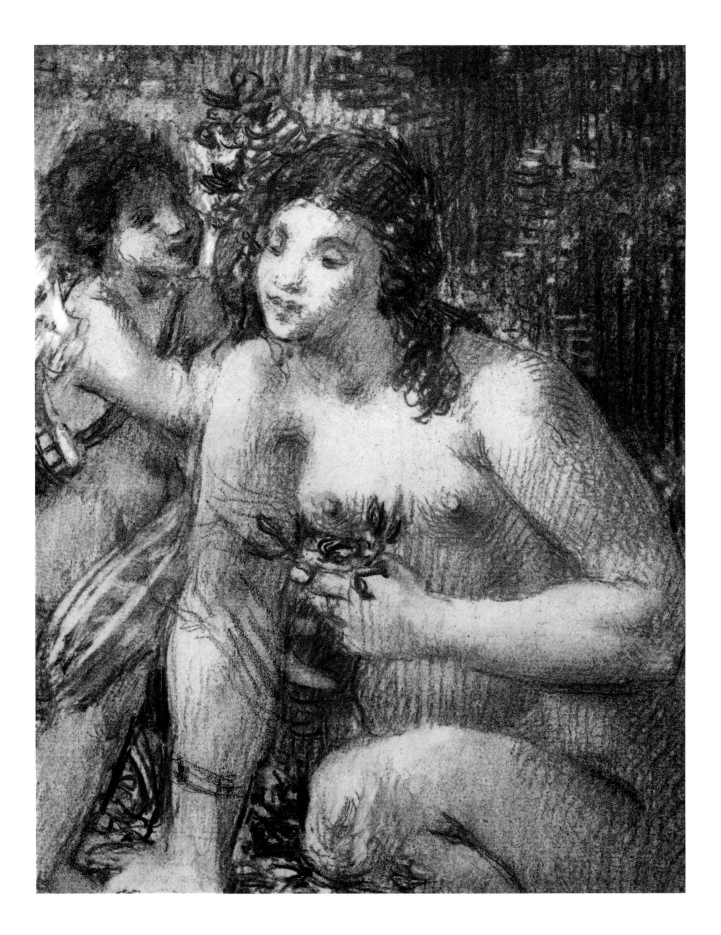

4 PEGGY BACON
1895–1987

Lady on Front Porch

ca. 1930
Ink
9¾ x 8 (24.8 x 20.3)
Signed l.c. *P.B.*

PROVENANCE | Kraushaar Galleries, New York
Adler Collection, 1982

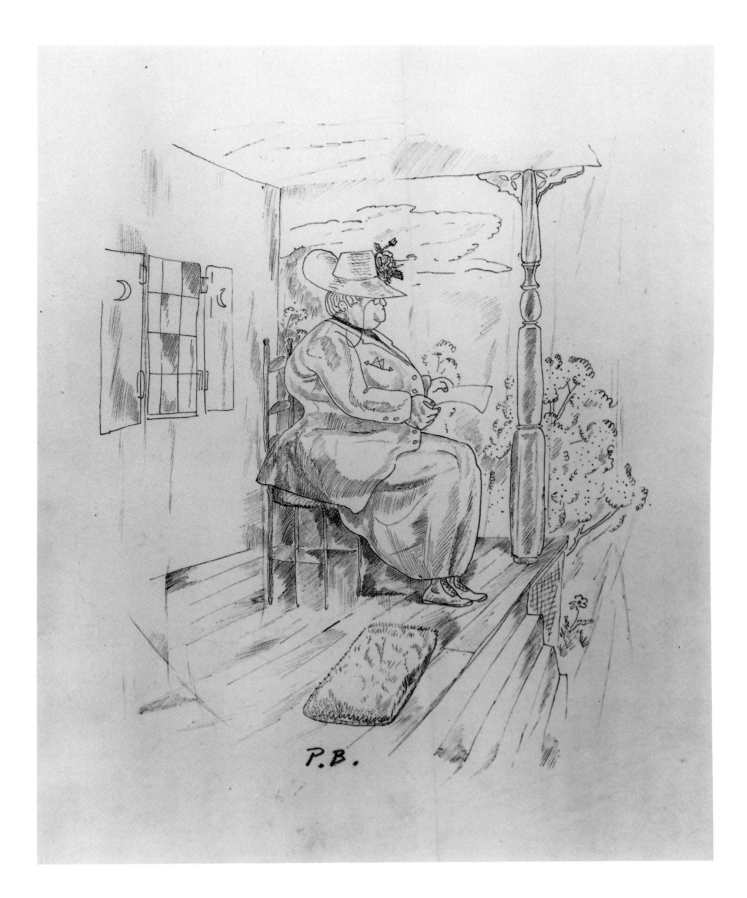

5 GEORGE BELLOWS
1882–1925

Lady of 1860

1922
Conté crayon
14 X 11 (35.6 X 27.9)
Signed l.r. *G B*

PROVENANCE	H. V. Allison & Co., New York T. E. Hanley, Bradford, Pennsylvania ACA American Masters, New York Adler Collection, 1969
EXHIBITED	*Exhibition of Drawings and Lithographs by George Bellows*, H. V. Allison & Co., New York, 1941. Neuberger Museum, 1977, no. 1.
REFERENCES	George Bellows, ''Records of Pictures,'' book B, p. 267; unpublished, in possession of H. V. Allison & Co., New York. Neuberger Museum, 1977, p. 2, illus. p. 3.

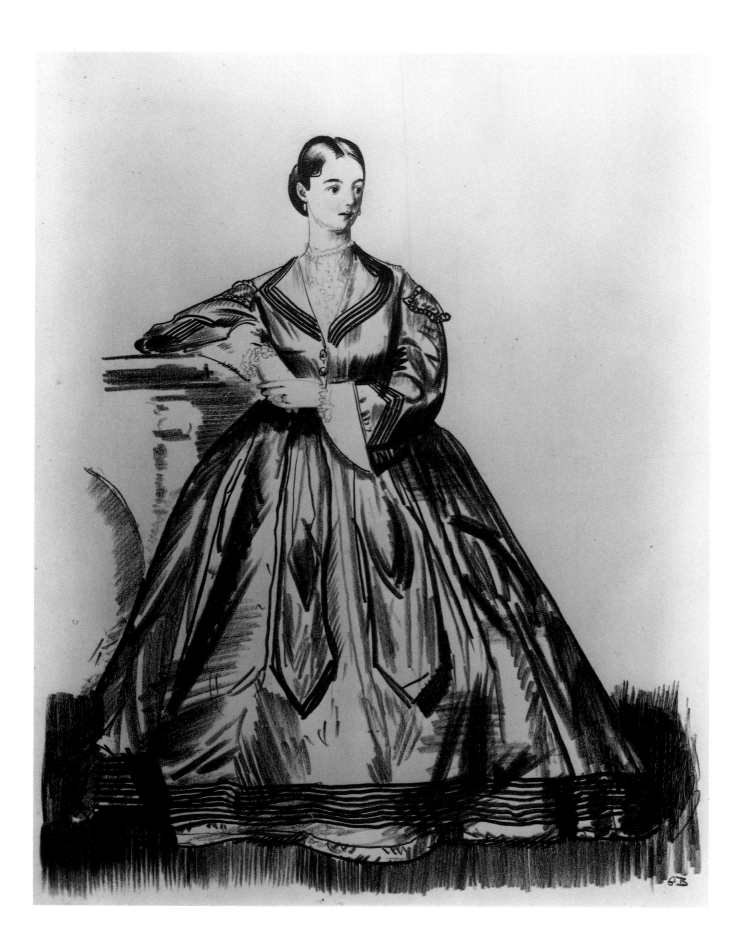

6 ISABEL BISHOP
1902–1988

Two Girls, Study

1934
Ink and wash
9¼ x 6 (23.5 x 15.2)
Signed l.l. *Isabel Bishop*

PROVENANCE	Midtown Galleries, New York Adler Collection, 1974
EXHIBITED	*Isabel Bishop*, University of Arizona Museum of Art, Tucson, and traveling, 1974–75, no. 66. Neuberger Museum, 1977, no. 4.
REFERENCE	Neuberger Museum, 1977, p. 8, illus. p. 9.

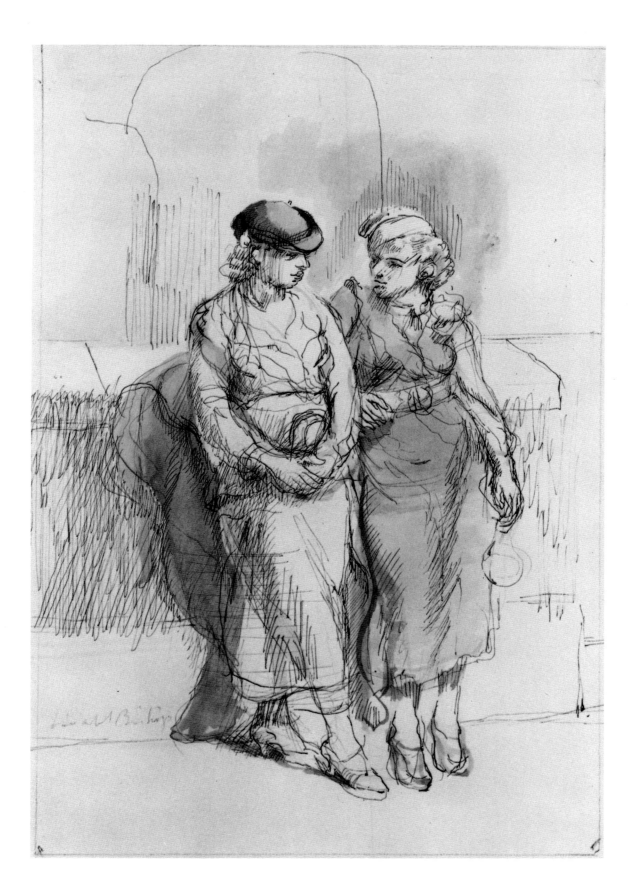

7 EMIL BISTTRAM
1895–1976

Pearls and Things and Palm Beach

1925
Watercolor
16¾ x 11⅝ (42.5 x 29.5)
Signed l.r. *EJB*

For the brochure *Pearls and Things and Palm Beach* / *Greenleaf & Crosby Co*,
The Breakers, Palm Beach, Florida 1925.

PROVENANCE | Estate of the artist
Martin Diamond Fine Arts, New York
Adler Collection, 1982

REFERENCE | Patricia Bayer, *Art Deco Source Book* (London: Quarto Publishing, 1988),
p. 147, color illus. p. 147.

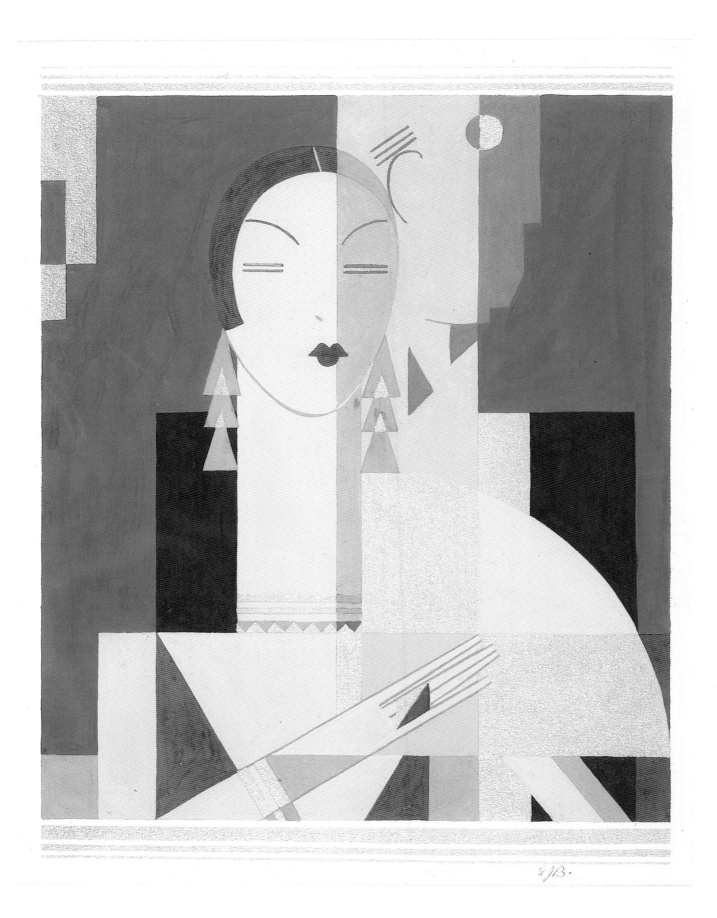

8 EMIL BISTTRAM
1895–1976

Time Cycle #1

1940
Charcoal
18 x 16 (45.7 x 40.6)
Signed l.r. *BISTTRAM*

PROVENANCE	Lauren Harris Martin Diamond Fine Arts, New York Adler Collection, 1982
EXHIBITED	*Four Decades of American Modernism, 1902–1942*, Martin Diamond Fine Arts, New York, 1982.
REFERENCES	Emil Bisttram, "The New Vision in Art," *Tomorrow* 1, no. 1 (September 1941), pp. 37–38, illus. p. 38. Robert C. Hay, "Dane Rudhyar and the Transcendental Painting Group of New Mexico from 1938–1941," M.A. thesis, Michigan State University, 1981, pp. 207–9, illus. p. 208.

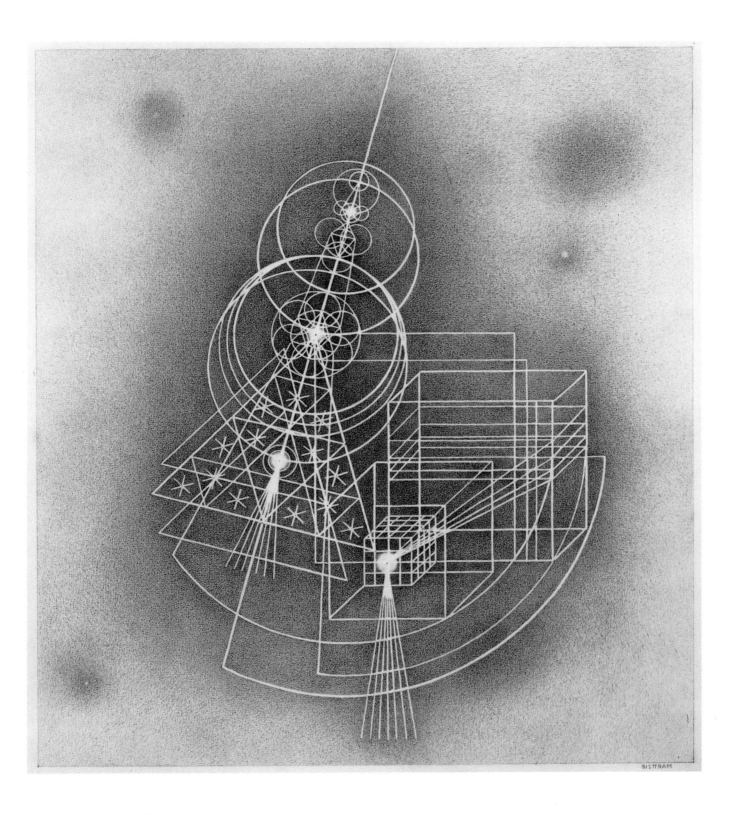

9 OSCAR BLUEMNER
1867–1938

Venus

1924
Watercolor
10 × 13 (25.4 × 33.0)
Signed l.l. *BLÜMNER*

PROVENANCE

Estate of the artist
James Graham & Sons, New York
Henry Heiman II, South Salem, New York
Bernard Danenberg Galleries, New York
Dr. and Mrs. Max Ellenberg, New York
ACA Galleries, New York
Adler Collection, 1975

EXHIBITED

Exhibition of Watercolors by Oscar Bluemner, Mrs. Liebman's Art Room, New
York, 1926.
Oscar Florianus Bluemner, University Gallery, University of Minnesota,
Minneapolis, 1939, no. 49.
Retrospective Exhibition: Oscar F. Bluemner, 1867–1938, James Graham & Sons,
New York, 1956, no. 25.
Columbus Gallery of Fine Arts, Columbus, Ohio, 1960.
The Twenties Revisited, Gallery of Modern Art, New York, 1965.
Oscar Bluemner: Paintings, Watercolors, and Drawings, Bernard Danenberg
Galleries, New York, 1972, no. 63.
Neuberger Museum, 1977, no. 8.
Oscar Bluemner: The New Jersey Years, Ramapo College Art Gallery, Mahwah,
N.J., 1982, no. 50.
Oscar Bluemner: A Retrospective Exhibition, Barbara Mathes Gallery, New York,
1985, no. 11.
Oscar Bluemner: Landscapes of Sorrow and Joy, Corcoran Gallery of Art,
Washington, D.C., and traveling, 1988–89, no. 66.

REFERENCES

Oscar F. Bluemner Papers, "Painting Diaries," 20 November 1924, no. 28,
Archives of American Art, Washington, D.C., roll 340, frame 1409.
Neuberger Museum, 1977, p. 14, illus. p. 15.
Jeffrey R. Hayes, "Oscar Bluemner: Life, Art, and Theory," Ph.D.
dissertation, University of Maryland, 1982, pp. 290–91, illus. p. 505.
Jeffrey R. Hayes, *Oscar Bluemner: The New Jersey Years* (Mahwah, N.J.:
Ramapo College Art Gallery, 1982), p. 8, illus. p. 14.
Jeffrey R. Hayes, *Oscar Bluemner: A Retrospective Exhibition* (New York:
Barbara Mathes Gallery, 1985), p. 11, color illus. no. 11.
Jeffrey R. Hayes, *Oscar Bluemner: Landscapes of Sorrow and Joy* (Washington,
D.C.: Corcoran Gallery of Art, 1988), p. 44, color illus. p. 50.

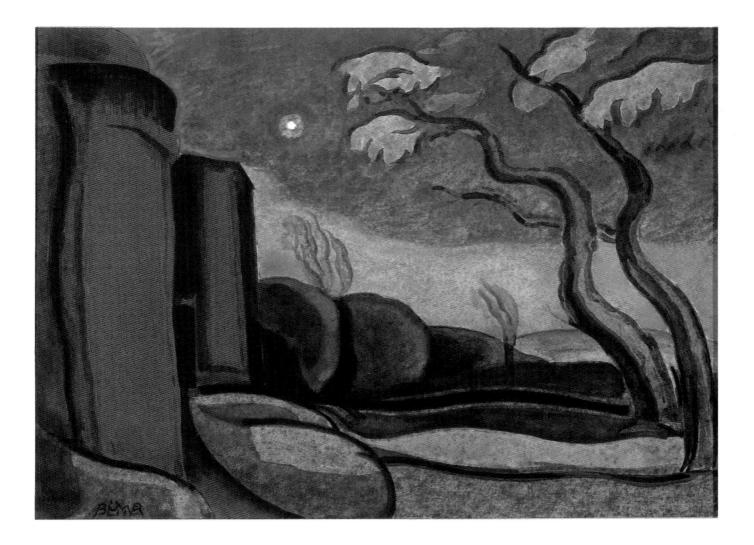

10 OSCAR BLUEMNER
1867–1938

November Moon (Moonrise)

1927
Watercolor
9½ x 12½ (24.1 x 31.7)
Signed l.l. *BLÜMNER*; label on back of frame signed, dated, and inscribed *Oscar Bluemner 1927 102 Plain Rd. S. Braintree, Mass*

PROVENANCE	Estate of the artist James Graham & Sons, New York Dr. and Mrs. Robert Mandelbaum, Brooklyn, New York Davis & Long Company, New York Adler Collection, 1977
EXHIBITED	*Oscar Bluemner: New Paintings*, Intimate Gallery, New York, 1928, no. 2. *Retrospective Exhibition: Oscar F. Bluemner, 1867–1938*, James Graham & Sons, New York, 1956, no. 36. Neuberger Museum, 1977 (not in catalogue). *American-English Paintings, Watercolors, and Drawings*, Davis & Long Company, New York, 1977 (not in catalogue). *Oscar Bluemner: A Retrospective Exhibition*, Barbara Mathes Gallery, New York, 1985, no. 13. *The Expressionist Landscape*, Birmingham Museum of Art, Birmingham, Ala., and traveling, 1987–88, no. 8. *Oscar Bluemner: Landscapes of Sorrow and Joy*, Corcoran Gallery of Art, Washington, D.C., and traveling, 1988–89, no. 72.
REFERENCES	Oscar F. Bluemner Papers, "Painting Diaries," 4 February 1927, no. 60, Archives of American Art, Washington, D.C., roll 340, frames 1703, 1705. Jeffrey R. Hayes, "Oscar Bluemner: Life, Art, and Theory," Ph.D. dissertation, University of Maryland, 1982, pp. 326–27, illus. p. 513. Jeffrey R. Hayes, *Oscar Bluemner: A Retrospective Exhibition* (New York: Barbara Mathes Gallery, 1985), p. 11, color illus. no. 13. Grace Glueck, "Art: Oscar Bluemner," *New York Times*, 22 March 1985, p. C25. Jeffrey R. Hayes, "Theory and Practice: Hartley, Bluemner, and the Expressionist Landscape," in *The Expressionist Landscape* (Birmingham, Ala.: Birmingham Museum of Art, 1988), pp. 93, 185, color illus. p. 105. Jeffrey R. Hayes, *Oscar Bluemner: Landscapes of Sorrow and Joy* (Washington, D.C.: Corcoran Gallery of Art, 1988), p. 53, illus. p. 54.

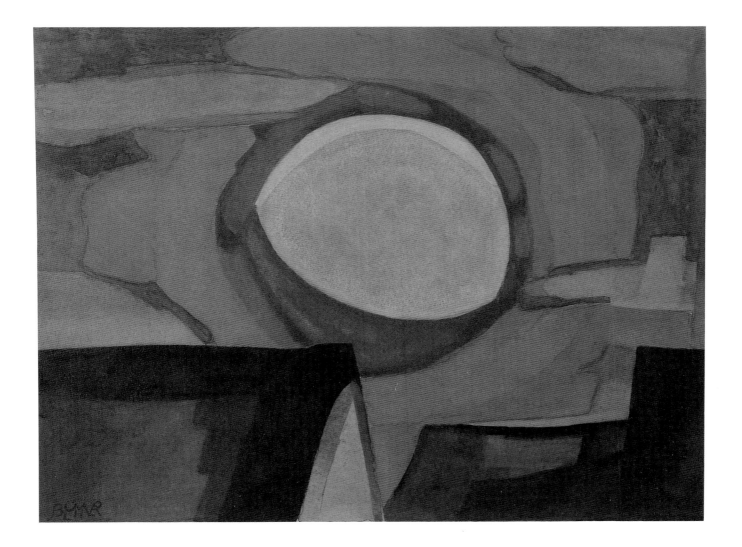

11 ROBERT FREDERICK BLUM
1857–1903

Study after "A Venetian Market"

1889
Ink
10½ x 6½ (26.7 x 16.5)

PROVENANCE | Jordan-Volpe Gallery, New York
Adler Collection, 1985

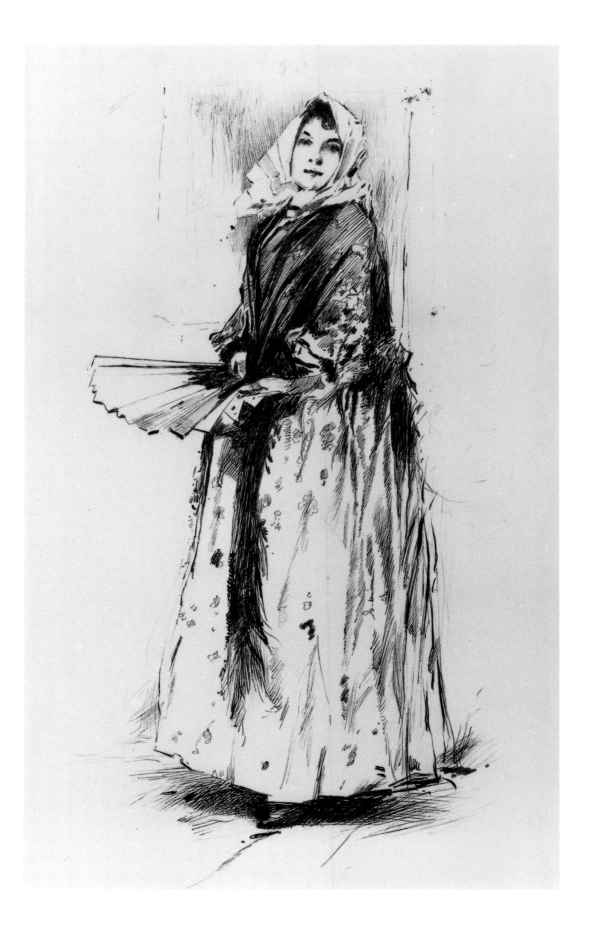

12 RUTHERFORD BOYD
1884–1951

Self-Portrait

1908
Pencil
9 x 7¾ (22.9 x 19.7)
Signed and dated l.r. *JOHN / RUTHERFORD / BOYD 1908*

PROVENANCE | Estate of the artist
Hirschl & Adler Galleries, New York
Adler Collection, 1982

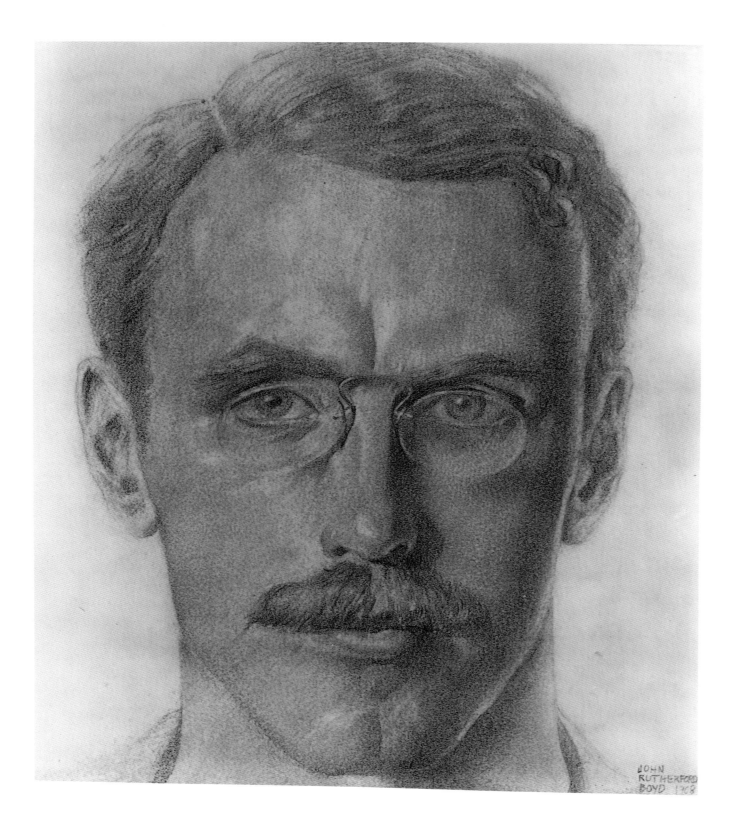

JOHN
RUTHERFORD
BOYD 1908

13 FIDELIA BRIDGES
1834–1923

Flowering Vine

ca. 1870–71
Watercolor
12 x 9 (30.5 x 22.9)

PROVENANCE	Oliver Ingraham Lay, Canaan, Connecticut
	George C. Lay
	Berry-Hill Galleries, New York
	Adler Collection, 1984
EXHIBITED	*Fidelia Bridges: American Pre-Raphaelite*, New Britain Museum of American Art, New Britain, Conn.; Berry-Hill Galleries, New York, 1981–82, no. 56.

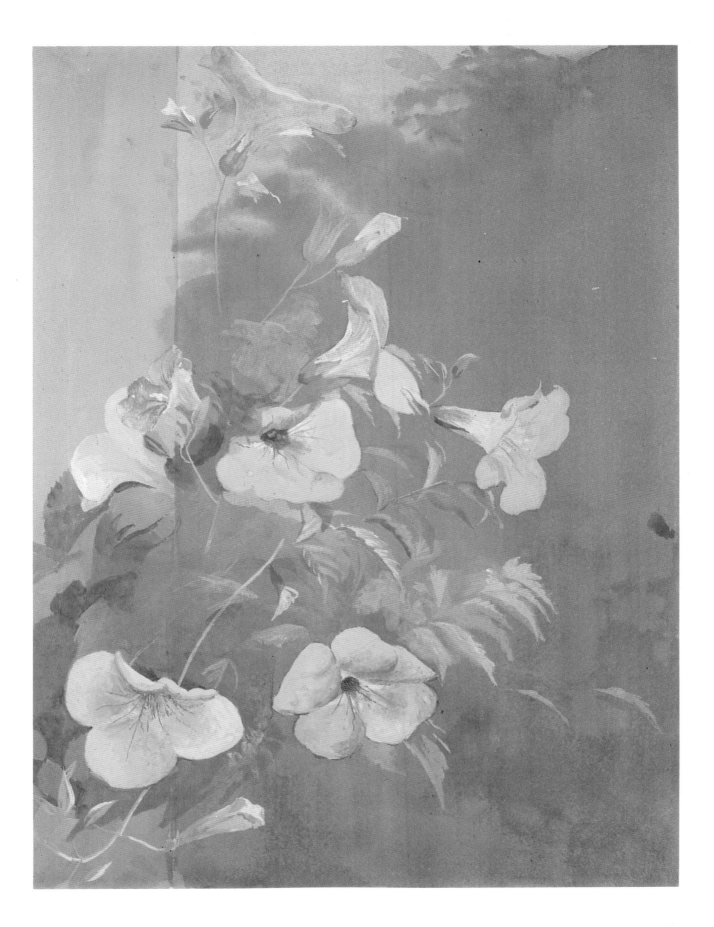

14 PAUL CADMUS
b. 1904

Old Lady

1922
Pencil
5⅝ x 4⅝ (14.3 x 11.7)
Signed and dated l.r. *P. Cadmus 1922*

PROVENANCE	Midtown Galleries, New York
	Adler Collection, 1971
EXHIBITED	*Winter Exhibition*, National Academy of Design, New York, 1922, no. 531.
	Retrospective Selection of Drawings and Prints, Midtown Galleries, New York, 1968.
	Neuberger Museum, 1977, no. 9.
REFERENCES	*Catalogue of the Winter Exhibition of the National Academy of Design* (New York: National Academy of Design, 1922), illus. no. 531.
	Una E. Johnson, *Paul Cadmus: Prints and Drawings, 1922–1967* (Brooklyn, N.Y.: Brooklyn Museum, 1968), p. 7, illus. no. 1.
	Neuberger Museum, 1977, p. 16, illus. p. 17.

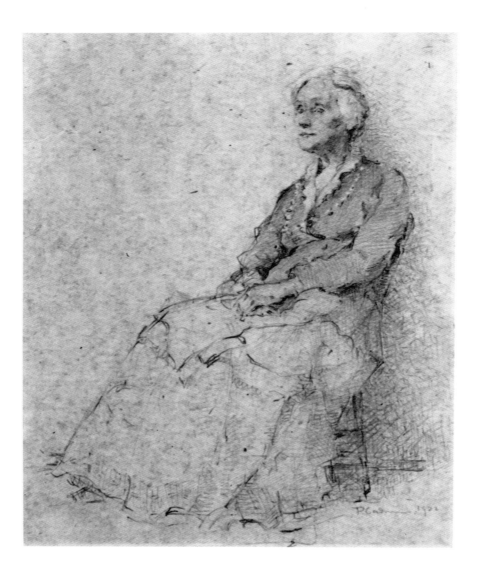

15 MARY CASSATT
1844–1926

Study for "Young Women Picking Fruit"

ca. 1892
Pencil
17¼ x 11 (43.8 x 27.9)
Signed l.r. *Mary Cassatt*

PROVENANCE	Durand-Ruel, Paris H. V. Allison & Co., New York Mrs. George A. Martin, Cleveland, Ohio Parke-Bernet Galleries, New York, sale no. 3292 David Bassine, New York Sotheby Parke-Bernet, New York, sale no. 3761 Hirschl & Adler Galleries, New York Adler Collection, 1977
EXHIBITED	*100 American Drawings and Watercolors from 200 Years*, Hirschl & Adler Galleries, New York, 1976, no. 15. Neuberger Museum, 1977, no. 10. *American Works of Art on Paper, 1850–1925*, Schenectady Museum, Schenectady, N.Y., 1980, no. 18.
REFERENCES	Adelyn Dohme Breeskin, *Mary Cassatt: A Catalogue Raisonné of the Oils, Pastels, Watercolors, and Drawings* (Washington, D.C.: Smithsonian Institution Press, 1970), p. 21, illus. p. 275, no. 818. Nancy Hale, *Mary Cassatt* (Garden City, N.Y.: Doubleday & Company, 1975), p. 105. *100 American Drawings and Watercolors from 200 Years* (New York: Hirschl & Adler Galleries, 1976), pp. 2, 9, illus p. 5. Neuberger Museum, 1977, p. 18, illus. p. 19. Kathie Beals, "Two Private Collections Go Public," *Westchester Weekend*, 2 December 1977, p. D7. *American Works of Art on Paper, 1850–1925* (Schenectady, N.Y.: Schenectady Museum, 1980), p. 23. Nancy Mowll Mathews, *Mary Cassatt* (New York: Harry N. Abrams, 1987), pp. 84, 86, 91, illus. no. 72.

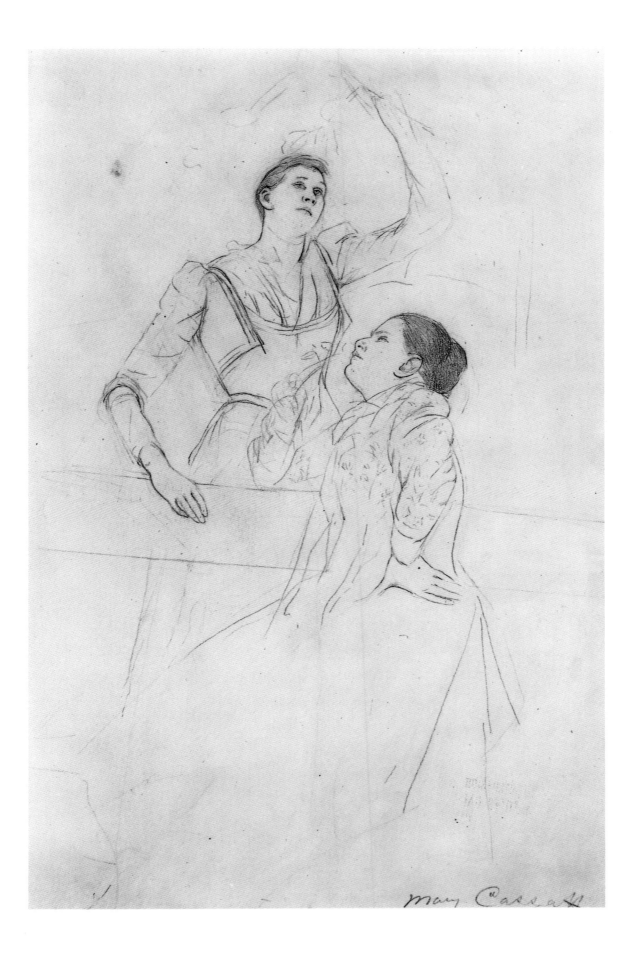

Mary Cassatt

16 JAMES WELLS CHAMPNEY
1843–1903

Indecision

1883
Watercolor
14¼ x 7⅞ (36.2 x 20.0)
Signed and dated l.r. *J. Wells Champney / 1883*

PROVENANCE	Paul Rich, Boston
	Peter Tillou, Litchfield, Connecticut
	Coe Kerr Gallery, New York
	Christie's, New York, sale no. 6402
	·Richard York Gallery, New York
	Adler Collection, 1987
EXHIBITED	*Sixteenth Annual Exhibition of the American Watercolor Society*, National Academy of Design, New York, 1883, no. 40.

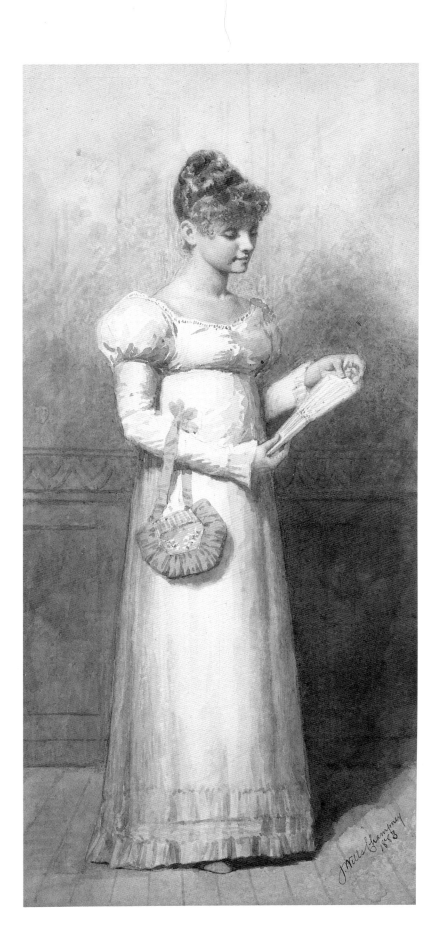

17 WILLIAM MERRITT CHASE
1849–1916

A Countryman

ca. 1882
Ink, crayon, and wash
18 x 13½ (45.7 x 34.3)
Signed l.r. *Chase*

	For Susan N. Carter, "Street Life in Madrid," *Century Magazine* 29 (November 1889), p. 35.
PROVENANCE	Mannados Bookshop, New York Kennedy Galleries, New York Adler Collection, 1978
EXHIBITED	*Men of the Tile Club*, Lyman Allyn Museum, New London, Conn., 1945, no. 46. *American Drawings: Nineteenth and Twentieth Century*, Kennedy Galleries, New York, 1978. *American Works of Art on Paper, 1850–1925*, Schenectady Museum, Schenectady, N.Y., 1980, no. 19. *A Leading Spirit in American Art: William Merritt Chase*, Henry Art Gallery, University of Washington, Seattle; Metropolitan Museum of Art, New York, 1983–84, p. 54.
REFERENCE	*American Works of Art on Paper, 1850–1925* (Schenectady, N.Y.: Schenectady Museum, 1980), p. 23.

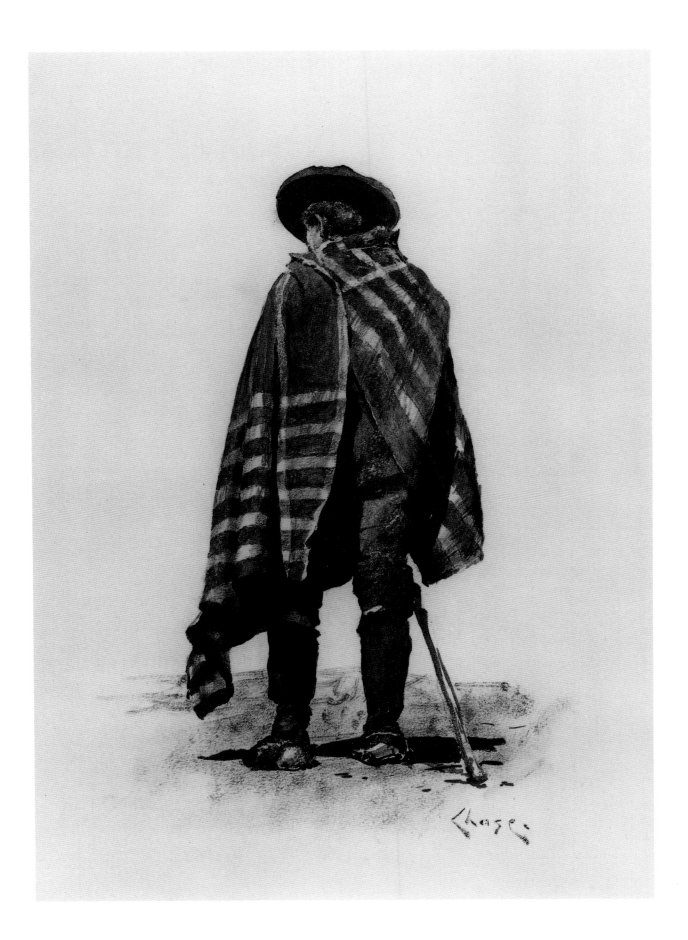

18 WILLIAM MERRITT CHASE
1849–1916

Mrs. William Merritt Chase (Spanish Girl)

ca. 1886
Gouache and ink
9¹⁄₁₆ x 6¼ (23.0 x 15.9)
Signed c.l. *Chase*

PROVENANCE	Edwin S. Chapin, Jr.
	Florence Lewison Gallery, New York
	Mr. and Mrs. Maurice Glickman, New York
	Ronald G. Pisano, Inc., New York
	Adler Collection, 1984
EXHIBITED	*William Merritt Chase*, Boston Arts Club, 1886, no. 131.

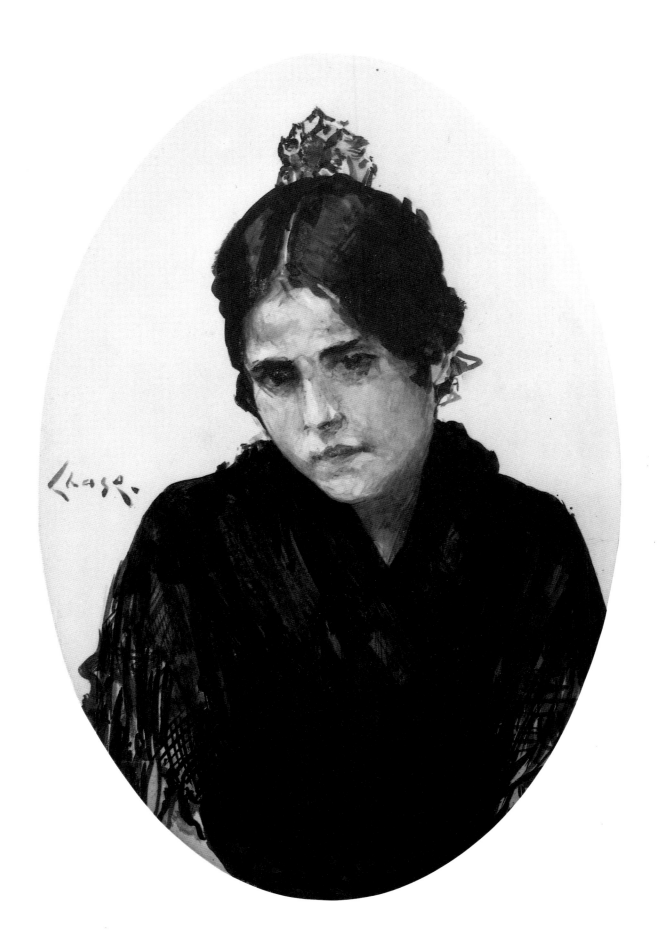

19 JOSEPH CORNELL
1903–1972

The Ocean
(recto and verso)

n.d.
Collage
12 x 8¾ (30.5 x 22.2)
Verso signed and inscribed l.c. *The Ocean / Joseph Cornell*

❖

PROVENANCE | Private collection, New York
Carlton Galleries, New York
ACA Galleries, New York
Adler Collection, 1984

EXHIBITED | *Important Nineteenth- and Early-Twentieth-Century Paintings and Drawings,*
 Heath Gallery, Atlanta, Ga., 1981.

verso

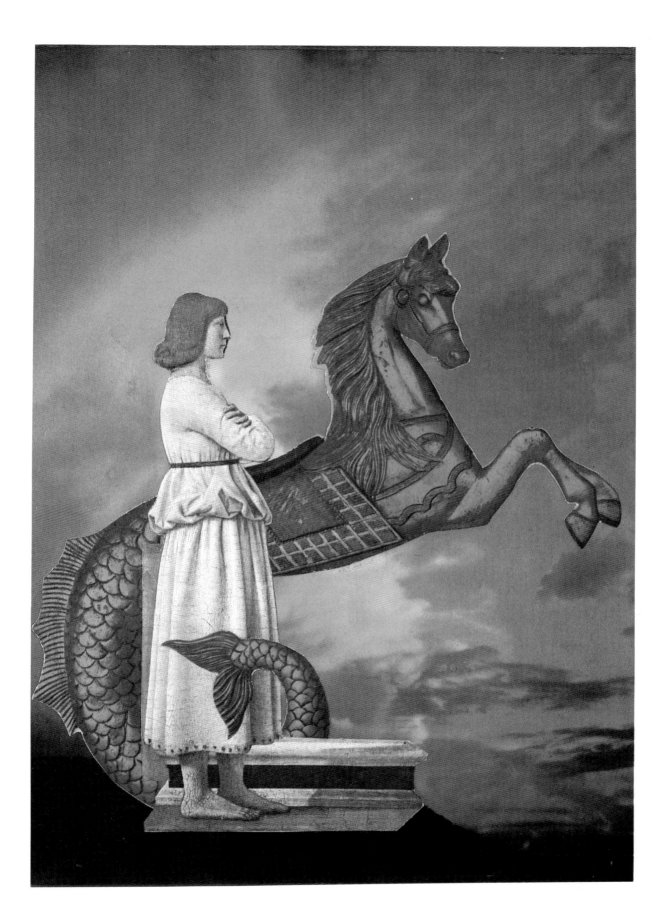

20 ARTHUR B. DAVIES
1862–1928

Prancing Nude

ca. 1925
Pastel
10 x 7½ (25.4 x 19.0)
Signed l.l. *A. B. DAVIES*

PROVENANCE | Estate of the artist
ACA Galleries, New York
Chapellier Gallery, New York
Adler Collection, 1967

EXHIBITED | *Graphic Styles of the American Eight*, Utah Museum of Fine Arts, University of Utah, Salt Lake City, 1976, no. 9.
Neuberger Museum, 1977, no. 11.

REFERENCES | Sheldon Reich, *Graphic Styles of the American Eight* (Salt Lake City: Utah Museum of Fine Arts, University of Utah, 1976), p. 15, illus. p. 31.
Neuberger Museum, 1977, p. 20, illus. p. 21.

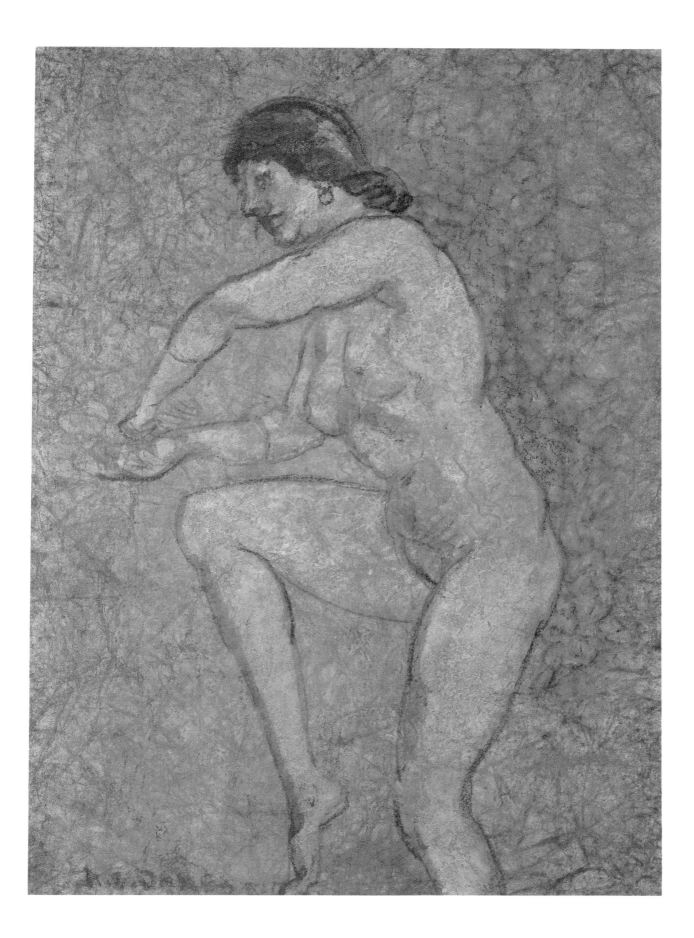

21

JOSEPH R. DE CAMP
1858–1923

Portrait of Peggy Wood

ca. 1910
Pencil and pastel
21 x 13½ (53.3 x 34.3)
Artist's monogram l.r.

PROVENANCE	Cincinnati Art Galleries, Cincinnati, Ohio
	John Curuby, Boston
	Comenos Fine Arts, Boston
	Adler Collection, 1988
EXHIBITED	*Panorama of Cincinnati Art II, 1850–1950*, Cincinnati Art Galleries, Cincinnati, Ohio, 1987, no. 6.
REFERENCE	"Joseph De Camp: Painter and Man," *American Magazine of Art* 14 (April 1923), p. 183, illus. p. 188.

22 PAUL DE LONGPRÉ
1855–1911

Ramblers

ca. 1900
Watercolor
12½ x 11¼ (31.7 x 28.6)
Signed l.l. *Paul de Longpré*

PROVENANCE | Anton Schutz
Mrs. Anton Schutz
Richard York Gallery, New York
Adler Collection, 1985

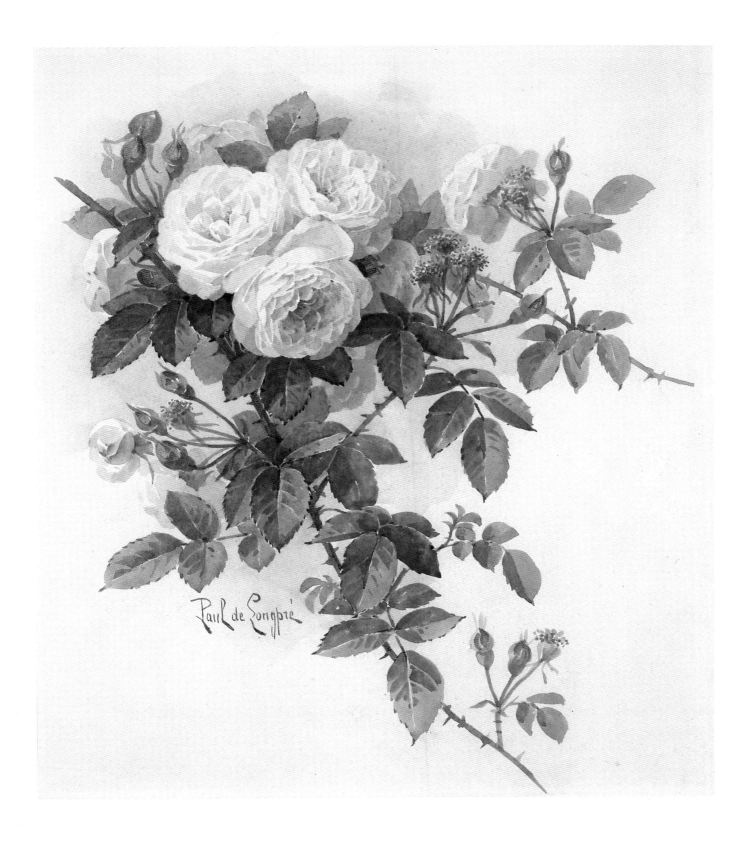

Paul de Longpré

23 THOMAS W. DEWING
1851–1938

A Study (Lady with Flowers)

ca. 1914
Pastel
13¾ x 10¼ (34.9 x 26.0)
Signed and inscribed l.r. *T W Dewing* / *200*

PROVENANCE	Gage Gallery, Cleveland, Ohio
	Mrs. George Martin, Cleveland, Ohio
	Sotheby Parke-Bernet, New York, sale no. 3348
	Rita and Daniel Fraad, Scarsdale, New York
	Davis & Long Company, New York
	Adler Collection, 1976
EXHIBITED	*American Painting*, Davis & Long Company, New York, 1976, no. 12.
	Neuberger Museum, 1977, no. 12.
REFERENCES	"Arts Reviews: American Painting," *Arts Magazine* 51 (December 1976), pp. 27–28.
	Neuberger Museum, 1977, p. 22, illus. p. 23.

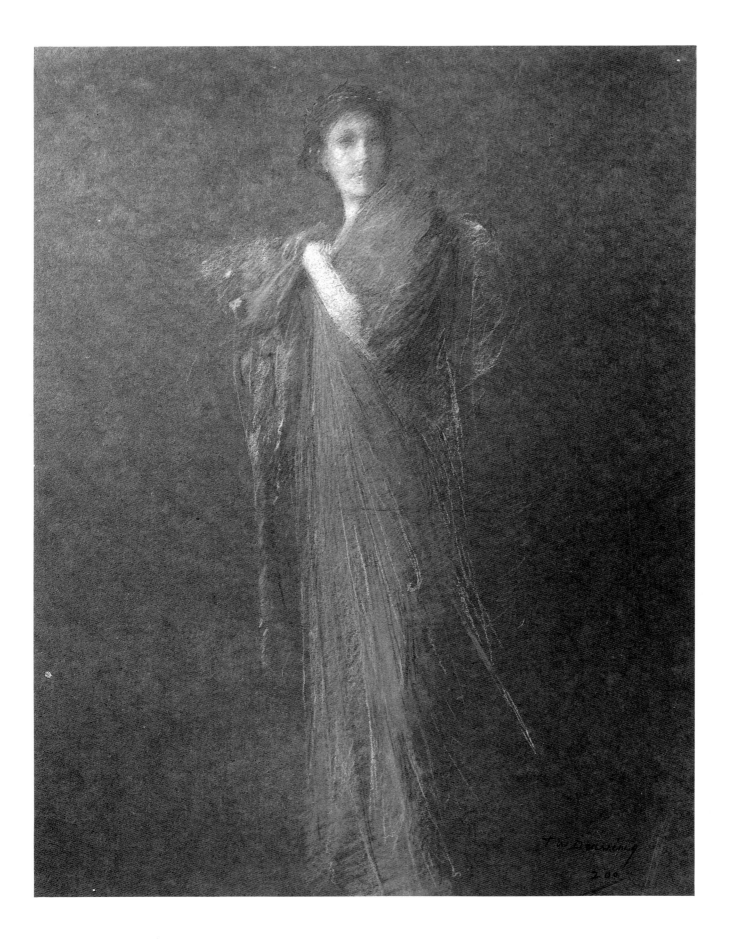

24 WALT DISNEY STUDIOS
(inked by Jack King)

Mickey Mouse (Doden-Doden Da Da-Dah)

1929
Ink
7½ x 6 (19.0 x 15.2)

PROVENANCE	Walt Disney Studios, Los Angeles, California
	Jerry Muller, Costa Mesa, California
	Puck Gallery, New York
	Adler Collection, 1974
EXHIBITED	*Mickey Mouse, 1928–1978*, Charles W. Bowers Museum, Santa Ana, Calif., 1978, no. 9.
REFERENCE	"Mickey Mouse in Tin Pan Alley," *College Humor* 94 (October 1931), p. 31, illus. p. 31.

25

GIUSEPPE FAGNANI
1819–1873

Melpomene

1869
Charcoal
11½ x 8½ (29.2 x 21.6)

PROVENANCE | Phillips, New York, sale no. 159
Hirschl & Adler Galleries, New York
Adler Collection, 1979

26 ELLEN THAYER FISHER
1847–1911

The Orange Bloom and the Myrtle Bay

1885
Watercolor
8 x 7¾ (20.3 x 19.7)
Signed l.c. next to branch *E. T. Fisher*; inscribed l.l. *The Orange Bloom and The Myrtle Bay*

PROVENANCE | Eleanor Fisher Grose (the artist's daughter)
Private collection
Ronald G. Pisano, Inc., New York
Adler Collection, 1984

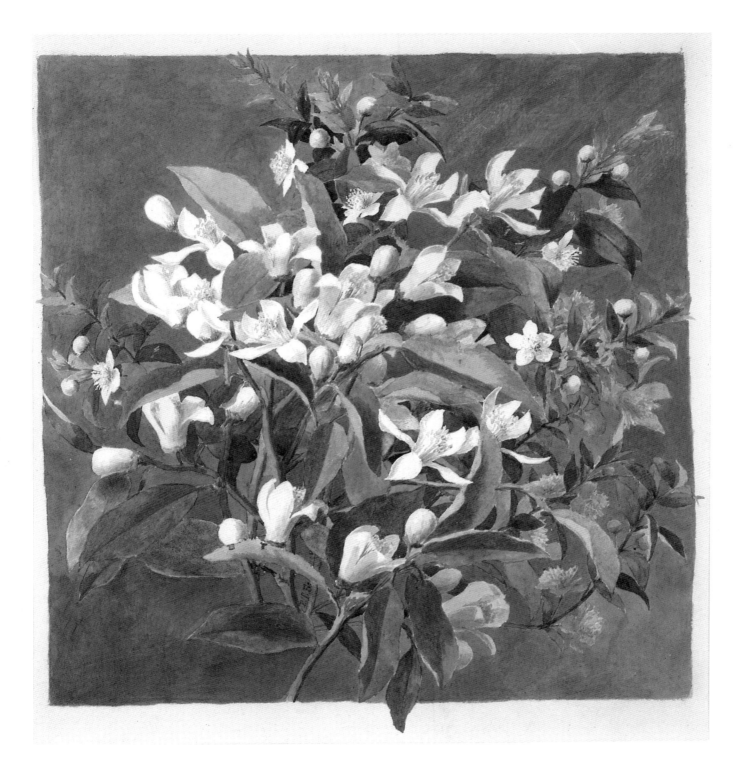

27 FREDERICK C. FRIESEKE
1874–1939

Morning Room

ca. 1922
Watercolor and pencil
12¼ x 9 (31.1 x 22.9)
Signed l.r. *F. C. Frieseke*

PROVENANCE	Macbeth Gallery, New York
	Joseph Sartor Galleries, Dallas, Texas
	Richard Feigen, Inc., New York
	Berry-Hill Galleries, New York
	Adler Collection, 1987
EXHIBITED	*Watercolors by Frederick C. Frieseke, N.A.*, Macbeth Gallery, New York, 1929.

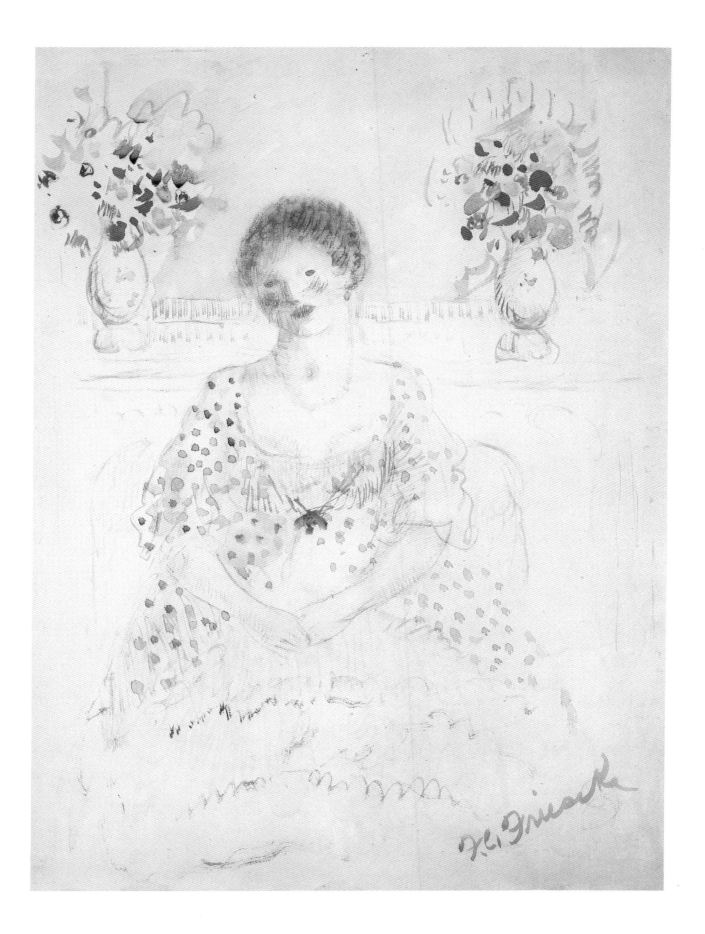

28 WILLIAM GLACKENS
1870–1938

Gloriana! Come on, Gloriana!

1907
Crayon, Chinese white, pencil, wash, and ink
6¾ x 7¼ (17.1 x 18.4)
Signed l.l. *W Glackens*

For Jacques Futrelle, "Enter the Duke (Batty Logan Stakes a Rival and Plays at Providence)," *Saturday Evening Post*, 17 August 1907, pp. 8–10, 23, illus. p. 9.

PROVENANCE

A. R. Blackmon, Jr.
Sotheby Parke-Bernet, New York, sale no. 3823
Kraushaar Galleries, New York
Adler Collection, 1976

EXHIBITED

Neuberger Museum, 1977, no. 14.
William Glackens: Illustrator in New York, 1897–1919, Delaware Art Museum, Wilmington, and traveling, 1985, no. 32.

REFERENCE

Neuberger Museum, 1977, p. 26, illus. p. 27.

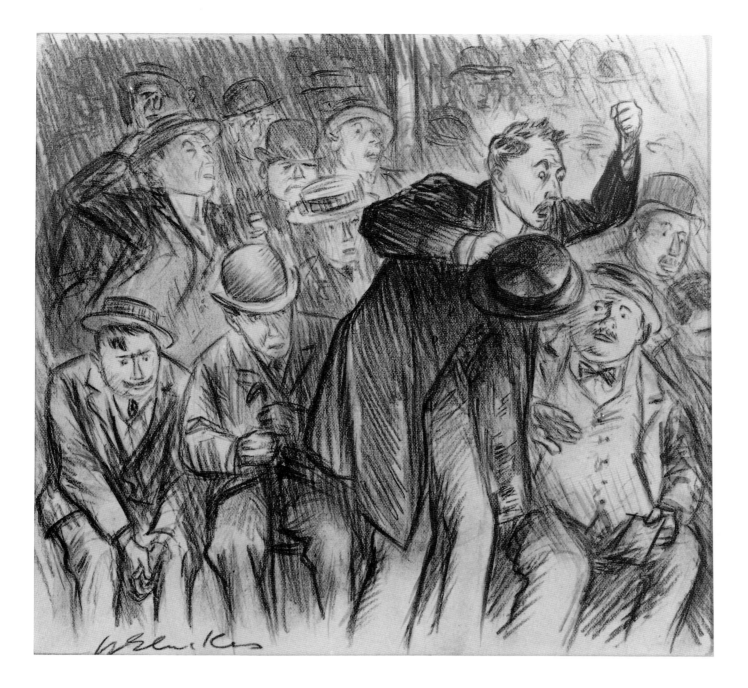

29 GEORGE GROSZ
1893–1959

Mann im Mond

ca. 1924
Ink
8 x 6 (20.3 x 15.2)
Signed l.r. *GROSZ*

PROVENANCE	Estate of the artist, no. 3-2-5
	The Art Fair, New York
	Adler Collection, 1967
EXHIBITED	Neuberger Museum, 1977, no. 16.
	All in Line, Lowe Art Gallery, Syracuse University, Syracuse, N.Y.; Terry Dintenfass, Inc., New York, 1980–81, no. 22.
REFERENCE	Neuberger Museum, 1977, p. 30, illus. p. 31.

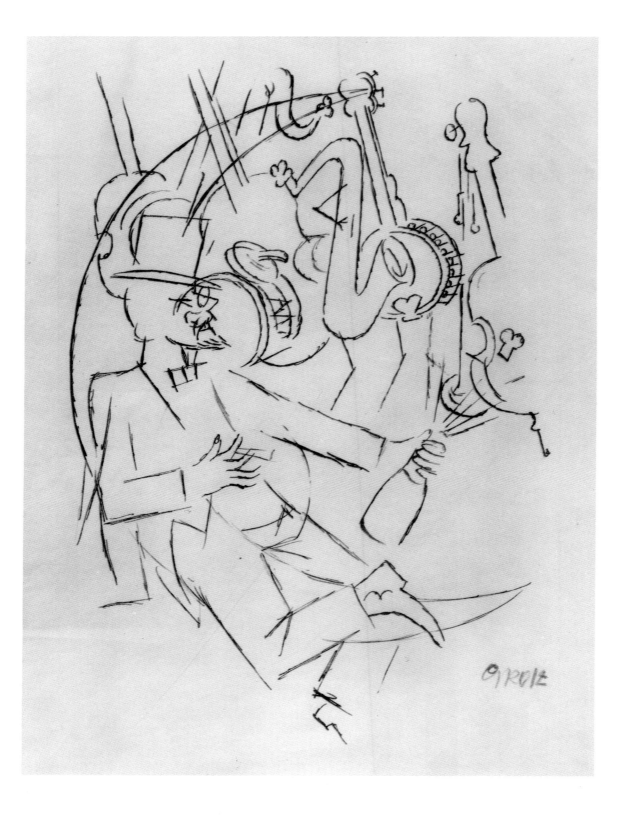

30 JOHN HABERLE
1856–1933

Head of a Man

1894
Charcoal
12⅝ x 9 (32.1 x 22.9)
Signed and dated l.l. *April 19th / 94 / Haberle*

PROVENANCE	Estate of the artist
	Hirschl & Adler Galleries, New York
	Adler Collection, 1977
EXHIBITED	Neuberger Museum, 1977 (not in catalogue).
	John Haberle: Master of Illusion, Museum of Fine Arts, Springfield, Mass., and traveling, 1985–86, no. 46.
REFERENCE	Gertrude Grace Sill, *John Haberle: Master of Illusion* (Springfield, Mass.: Museum of Fine Arts, 1985), p. 56, illus. p. 71.

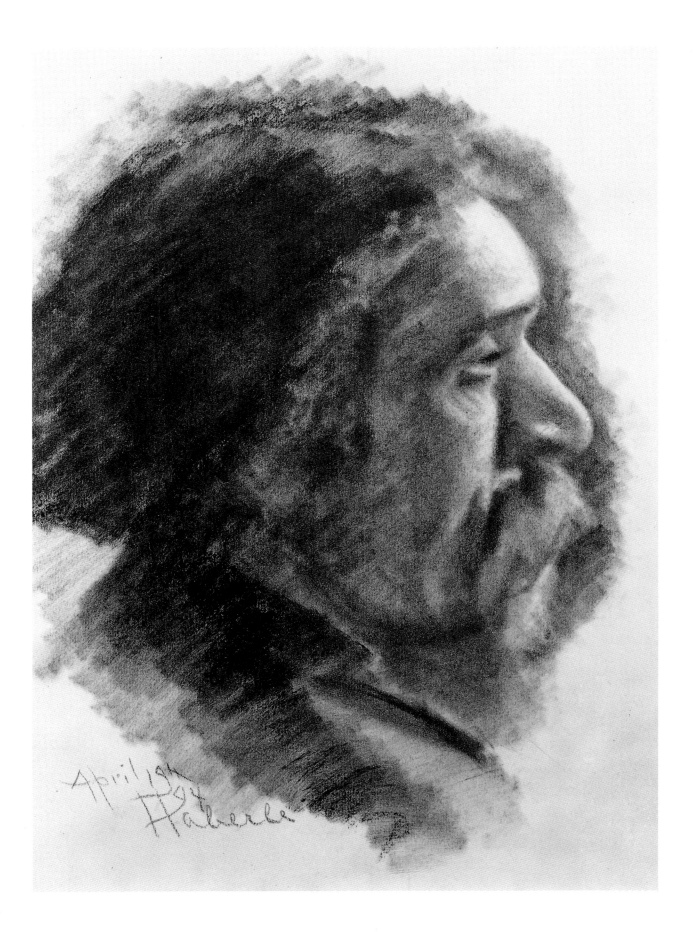

April 19
Haberle

31 LILIAN WESTCOTT HALE
1881–1963

The Artist's Mother (III)

ca. 1928
Charcoal
24¾ x 18¼ (62.9 x 46.4)

PROVENANCE	Estate of the artist
	Hirschl & Adler Galleries, New York
	Adler Collection, 1976
EXHIBITED	Neuberger Museum, 1977, no. 19.
REFERENCE	Neuberger Museum, 1977, p. 36, illus. p. 37.

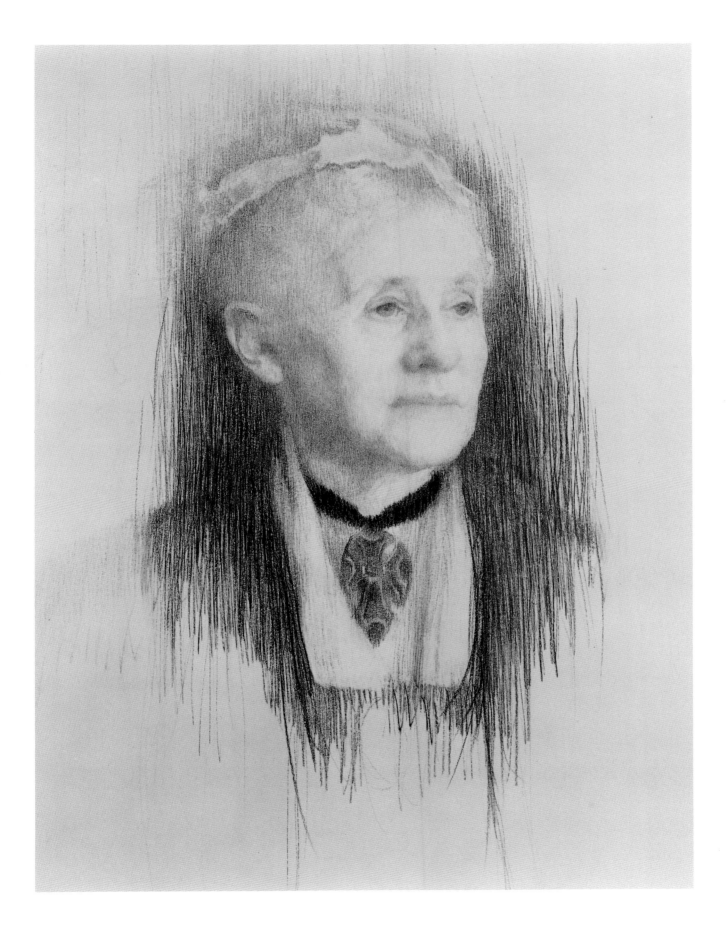

32 WILLIAM M. HARNETT
1848–1892

Iris

ca. 1870
Pencil, India ink, and wash
8¾ x 6¾ (22.2 x 17.1)
Signed l.c. on stem HARNETT

PROVENANCE	George P. Guerry, New York
	Ferdinand Davis, New York
	Kennedy Galleries, New York
	Adler Collection, 1976
EXHIBITED	Neuberger Museum, 1977, no. 20.
REFERENCES	Alfred Frankenstein, *After the Hunt* (Berkeley: University of California Press, 1953), p. 164.
	Neuberger Museum, 1977, p. 38, illus. p. 39.
	Kathie Beals, "Two Private Collections Go Public," *Westchester Weekend*, 2 December 1977, p. D7.

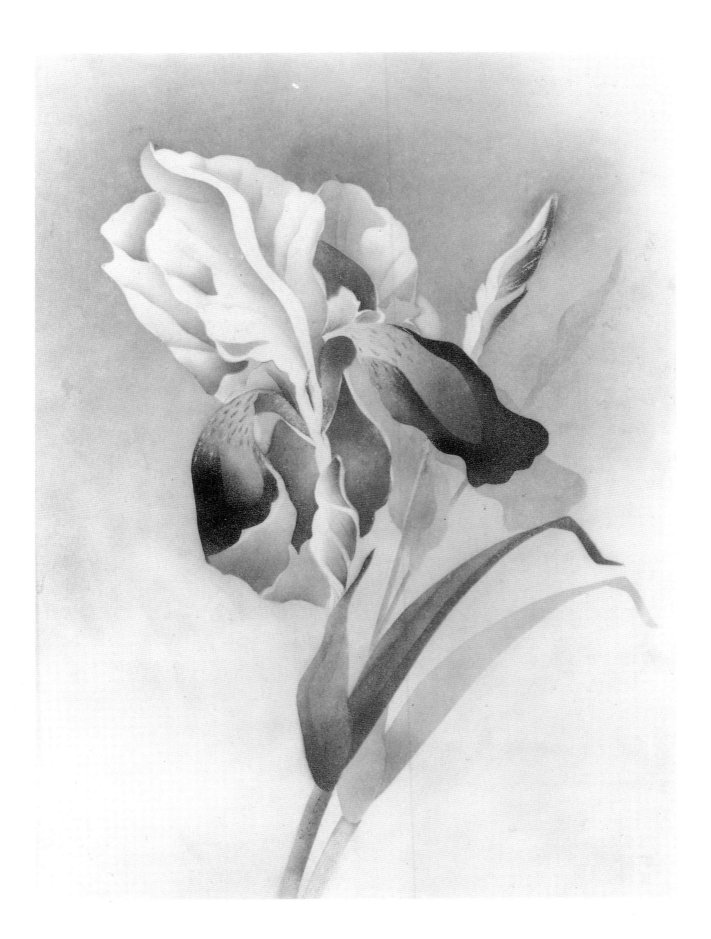

33 CHILDE HASSAM
1859–1935

San Pietro, Venice

1884
Watercolor
12 x 20 (30.5 x 50.8)
Signed, dated, and inscribed l.l. *Childe Hassam / 84 / San Pietro / Venice*

PROVENANCE	Mr. and Mrs. E. H. Letchworth, Buffalo, New York
	James Goodman Gallery, Buffalo, New York
	Hirschl & Adler Galleries, New York
	Milch Gallery, New York
	Dr. Theodore Leshner, Brooklyn, New York
	ACA Galleries, New York
	Adler Collection, 1974
EXHIBITED	*Exhibition of a Retrospective Group of Paintings, Childe Hassam, N.A.*, Buffalo Fine Arts Academy, Buffalo, N.Y., 1929, no. 96A.
	Neuberger Museum, 1977, no. 21.
	American Works of Art on Paper, 1850–1925, Schenectady Museum, Schenectady, N.Y., 1980, no. 42.
REFERENCES	Neuberger Museum, 1977, p. 40, illus. p. 41.
	Kathie Beals, "Two Private Collections Go Public," *Westchester Weekend*, 2 December 1977, p. D7.

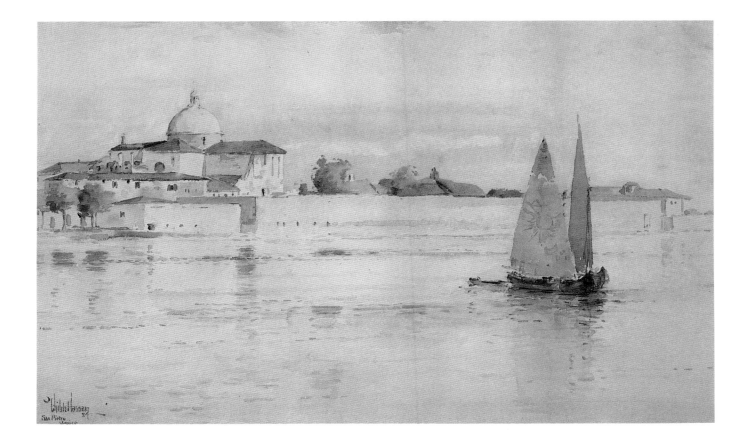

34 ROBERT HENRI
1865–1929

Portrait Head of a Woman

n.d.
Crayon
6½ x 4½ (16.5 x 11.4)
Signed l.l. *Robert Henri*

PROVENANCE	Estate of the artist
	John Le Clair, Glen Gardner, New Jersey
	Julian Foss, Verona, New Jersey
	ACA Heritage Gallery, New York
	Adler Collection, 1967
EXHIBITED	*Robert Henri: Painter-Teacher-Prophet*, New York Cultural Center, New York, 1969, no. 111.
	Graphic Styles of the American Eight, Utah Museum of Fine Arts, University of Utah, Salt Lake City, 1976, no. 48.
	Neuberger Museum, 1977, no. 23.
REFERENCE	Neuberger Museum, 1977, p. 44, illus. p. 45.

35 WINSLOW HOMER
1836–1910

Over the Garden Wall

ca. 1879
Pencil
5¹³⁄₁₆ x 5⅛ (14.8 x 13.0)
Signed l.r. *W H*

PROVENANCE	Albert Rosenthal
	Macbeth Gallery, New York
	Mrs. Mahonri M. Young
	Brigham Young University, Provo, Utah, gift of Mrs. Young
	John Adams Fund, New York
	Hirschl & Adler Galleries, New York
	Adler Collection, 1975
EXHIBITED	*The American Scene: A Survey of the Life and Landscape of the Nineteenth Century,* Hirschl & Adler Galleries, New York, 1969, no. 45.
	Nineteenth- and Twentieth-Century Drawings and Prints, Joseph Faulkner-Main Street Galleries, Chicago, 1973, no. 58.
	Neuberger Museum, 1977, no. 24.
REFERENCE	Neuberger Museum, 1977, p. 46, illus. p. 47.

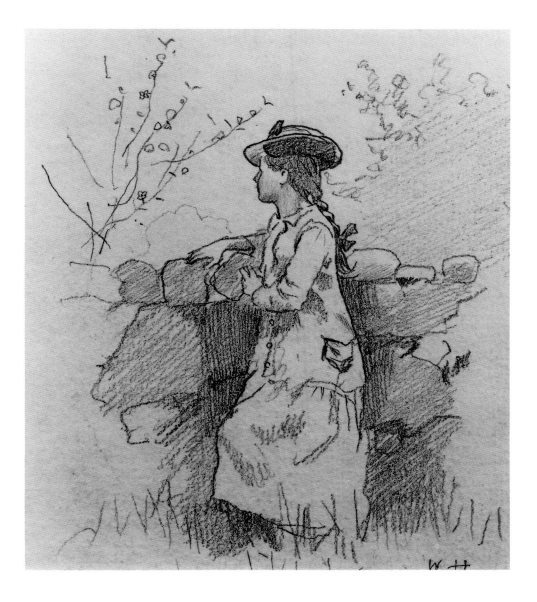

36 EASTMAN JOHNSON
1824–1906

Head of a Young Girl

ca. 1850
Charcoal and chalk
19 x 15 (48.3 x 38.1)
Signed l.l. *E. J.*

PROVENANCE

Castellane Gallery, New York
Mr. and Mrs. William Bender, Bronxville, New York
Estate of Mrs. William Bender
Sotheby Parke-Bernet, New York, sale no. 4048
Adler Collection, 1977

37 JOHN FREDERICK KENSETT
1816–1872

Standing Monk Holding Staff

ca. 1845–47
Pencil
9⅞ x 6¾ (25.1 x 17.1)

PROVENANCE	Vincent Colyer Louise Colyer Weed Edward F. Weed Isabel Weed Good Babcock Galleries, New York Adler Collection, 1979
EXHIBITED	*John F. Kensett Drawings*, Museum of Art, Pennsylvania State University, University Park; Babcock Galleries, New York, 1978, no. 15. *John Frederick Kensett: An American Master*, Worcester Art Museum, Worcester, Mass., and traveling, 1985–86.
REFERENCES	John Paul Driscoll, *John F. Kensett Drawings* (University Park: Museum of Art, Pennsylvania State University, 1978), pp. 41–42, 45, illus. p. 40. John Paul Driscoll and John K. Howat, *John Frederick Kensett: An American Master* (Worcester, Mass.: Worcester Art Museum, 1985), p. 58, illus. p. 58.

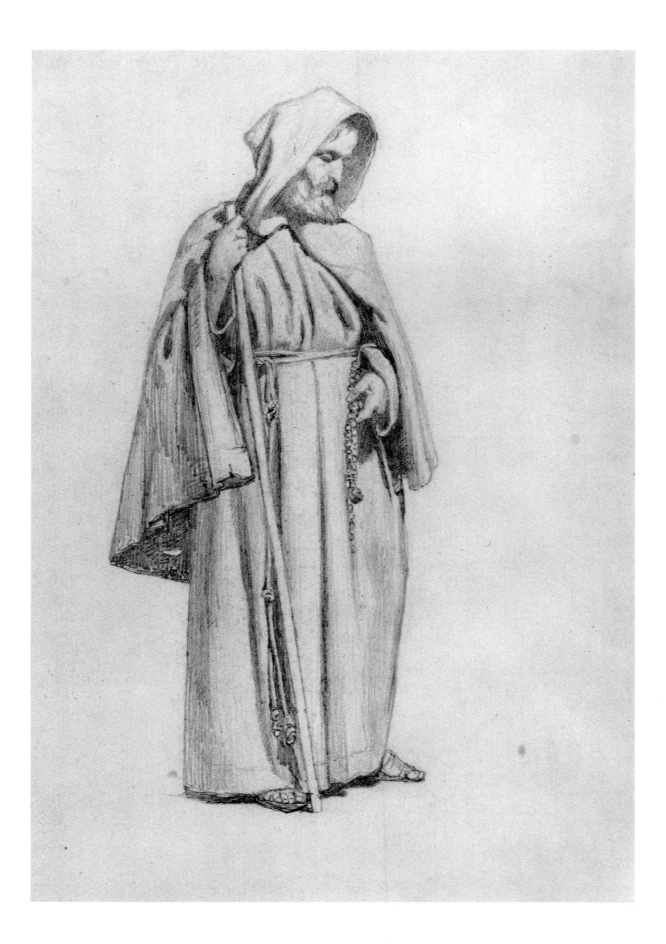

38 ROCKWELL KENT
1882–1971

Gunfighter

ca. 1920
Ink
5⅛ x 3¼ (13.0 x 8.3)

❖

PROVENANCE	Spector the Collector, New York
	Adler Collection, 1984
EXHIBITED	*Rockwell Kent: A Centennial*, New York Public Library, 1982, no. 11.

39 ROCKWELL KENT
1882–1971

Woman with a Drink

ca. 1920
Ink
6¼ x 3⅝ (15.9 x 9.2)
Estate stamp l.l.

PROVENANCE	Spector the Collector, New York
	Adler Collection, 1984
EXHIBITED	*Rockwell Kent: A Centennial*, New York Public Library, 1982, no. 11.

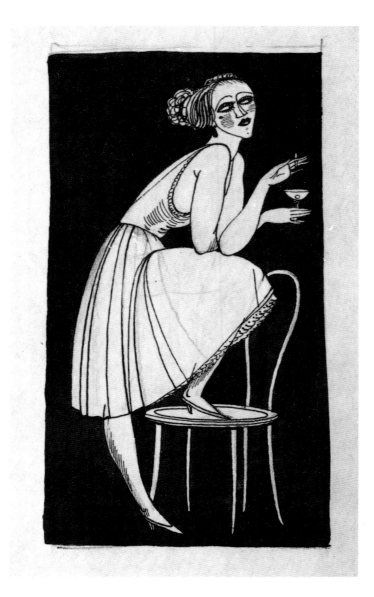

40 ROCKWELL KENT
1882–1971

The Pearl Necklace

ca. 1927
Ink
5¾ x 7½ (14.6 x 19.0)
Signed l.c. *Rockwell Kent*

PROVENANCE	Estate of the artist
	Kennedy Galleries, New York
	Adler Collection, 1984
EXHIBITED	*Nineteenth- and Twentieth-Century American Watercolors and Drawings,* Kennedy
	Galleries, New York, 1984.

41 LEON KROLL
1884–1974

Head of a Young Woman

1933
Charcoal
20 x 12 (50.8 x 30.5)
Signed l.r. *Leon Kroll*

PROVENANCE	Chapellier Gallery, New York
	Adler Collection, 1967
EXHIBITED	Neuberger Museum, 1977, no. 25.
REFERENCE	Neuberger Museum, 1977, p. 48, illus. p. 49.

42 LOUIS LOZOWICK
1892–1973

Machine Ornament #4

ca. 1925–27
Ink
11 × 9 (27.9 × 22.9)
Signed l.c. *LOUIS LOZOWICK*

PROVENANCE	Estate of the artist Zabriskie Gallery, New York Adler Collection, 1976
EXHIBITED	Zabriskie Gallery, New York, 1972. Neuberger Museum, 1977, no. 26.
REFERENCE	Neuberger Museum, 1977, p. 50, illus. p. 51.

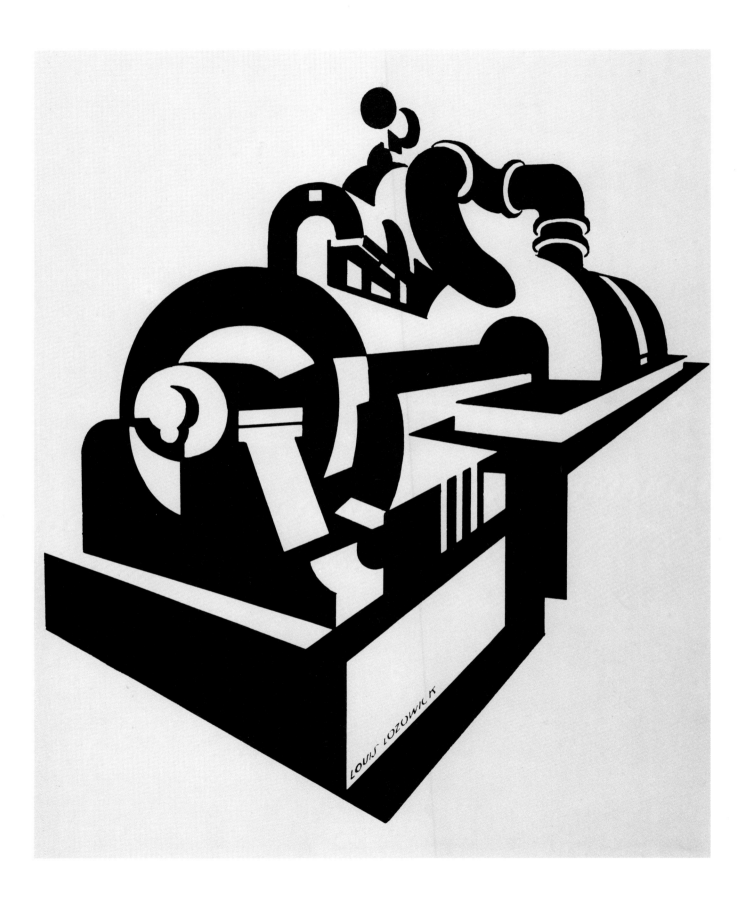

LOUIS LOZOWICK

43 LOUIS LOZOWICK
1892–1973

Smoke Stack

1929
Ink
10½ x 3¼ (26.7 x 8.3)
Artist's monogram l.l.

PROVENANCE | Estate of the artist
Zabriskie Gallery, New York
Adler Collection, 1977

EXHIBITED | *Louis Lozowick: Drawings and Lithographs*, National Collection of Fine Arts,
Smithsonian Institution, Washington, D.C., 1975, no. 13.
Urban Focus, Zabriskie Gallery, New York, 1976, no. 13.
Neuberger Museum, 1977 (not in catalogue).

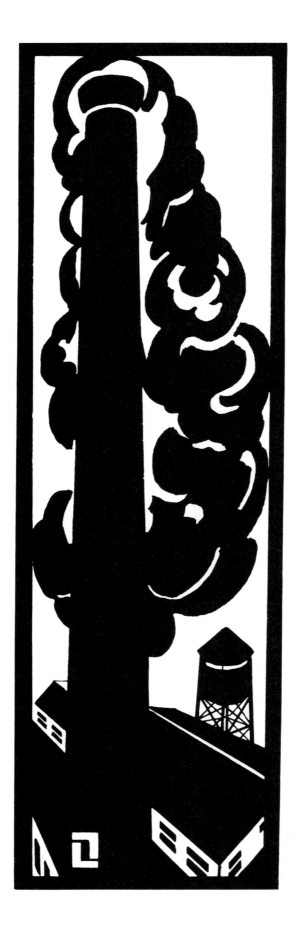

44 REGINALD MARSH
1898–1954

All Night Mission (recto)
Progress Hotel (verso)

1945
Recto: Chinese ink and wash; verso: Chinese ink and watercolor
30 x 22 (76.2 x 55.9)
Recto signed and dated l.r. *Reginald Marsh / 1945*

PROVENANCE | Gene Frey, Montclair, New Jersey
 | Dr. and Mrs. Milton Luria, Verona, New Jersey
 | ACA Galleries, New York
 | Mr. and Mrs. Keith Barish, New York
 | ACA Galleries, New York
 | Adler Collection, 1970

EXHIBITED | Neuberger Museum, 1977, no. 28.

REFERENCE | Neuberger Museum, 1977, p. 54, illus. p. 55.

verso

45 JAN MATULKA
1890–1972

Still Life with Guitar, Pears, Wine Pitcher, and Glass

ca. 1925
Charcoal
18 × 12 (45.7 × 30.5)
Signed l.r. *Matulka*

PROVENANCE	Robert Schoelkopf Gallery, New York
	Adler Collection, 1979
EXHIBITED	*American Drawings, 1927–1977*, Minnesota Museum of Art, Saint Paul, and traveling, 1977–79, no. 60.
REFERENCE	*American Drawings, 1927–1977* (Saint Paul: Minnesota Museum of Art, 1977), p. 7, illus. p. 6.

46 FRANCIS DAVIS MILLET
1846–1912

Lacing the Sandal
(Lady Tying Her Sandal)

ca. 1883
Watercolor
11 x 8½ (27.9 x 21.6)
Signed l.l. *F. D. Millet*

PROVENANCE	Hereward Lester Cooke, Washington, D.C. Berry-Hill Galleries, New York Adler Collection, 1988
EXHIBITED	*Sixteenth Annual Exhibition of the American Watercolor Society*, National Academy of Design, New York, 1883, no. 171. *Masters of the Medium: Important American Drawings, Pastels, and Watercolors*, Adams Davidson Galleries, Washington, D.C., 1988, no. 24.
REFERENCE	"The Watercolor Exhibition," *The Nation* 36 (15 February 1883), p. 157.

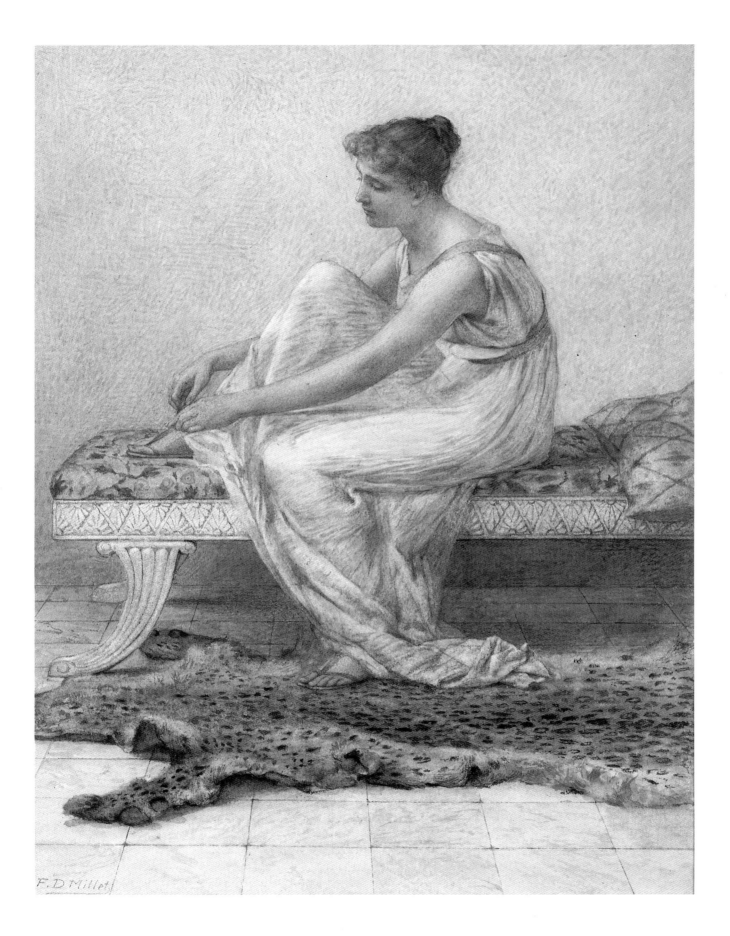

47 WALTER MURCH
1907–1967

Study for "Cyclops"

1957
Pencil
15 X 12 (38.1 X 30.5)
Signed u.r. *Walter Murch*

PROVENANCE	Betty Parsons Gallery, New York
	Private collection
	Forum Gallery, New York
	Adler Collection, 1984
EXHIBITED	*Walter Murch*, Betty Parsons Gallery, New York, 1970, no. 21.

48 ELIE NADELMAN
1885–1946

Seated Figure

ca. 1908–10
Ink
11¾ x 7¾ (29.8 x 19.7)
Signed l.r. *Elie Nadelman*

PROVENANCE | Madame Cassin-Vaillant, Paris
Madame Solange-Stern, Paris
Gustave Nooteboom, Amsterdam
Forum Gallery, New York
Adler Collection, 1976

EXHIBITED | Neuberger Museum, 1977, no. 31.
Sculpture (Early Works): Chaim Gross, Gaston Lachaise, Elie Nadelman, Hugo Robus, Forum Gallery, New York, 1978.
All in Line, Lowe Art Gallery, Syracuse University, Syracuse, N.Y.; Terry Dintenfass, Inc., New York, 1980–81, no. 49.

REFERENCE | Neuberger Museum, 1977, p. 58, illus. p. 59.

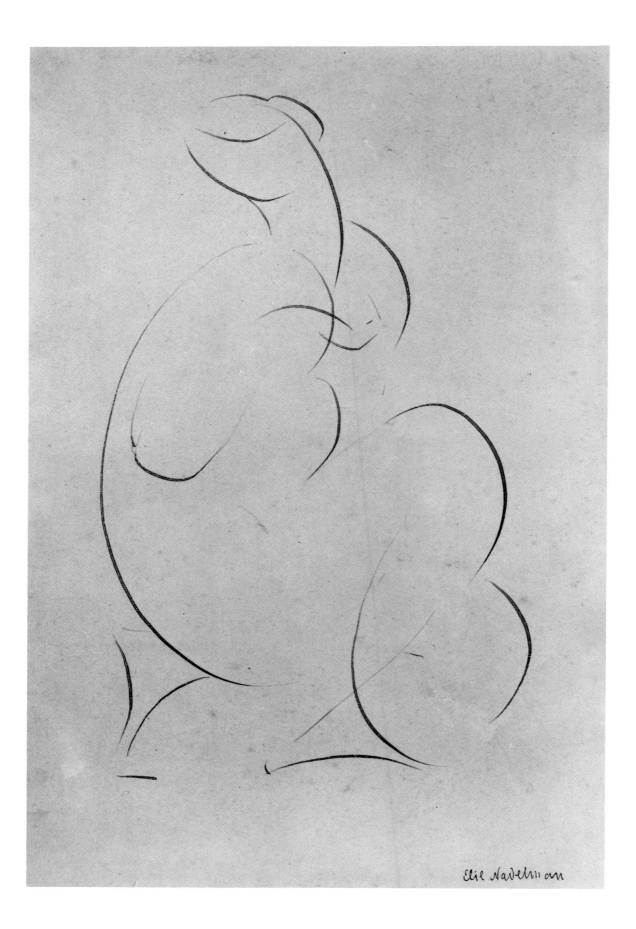

Elie Nadelman

49 JULES PASCIN
1885–1930

Feuille d'Etudes

ca. 1902
Watercolor
6¾ x 6¾ (17.1 x 17.1)
Signed l.l. *Pascin*

PROVENANCE	Perls Galleries, New York
	Richard Weininger, Bedford, New York
	Adler Collection, 1971
EXHIBITED	Neuberger Museum, 1977, no. 32.
REFERENCE	Neuberger Museum, 1977, p. 60, illus. p. 61.

50 JULES PASCIN
1885–1930

Street Workers

ca. 1919
Watercolor
7½ x 10 (19.1 x 25.4)
Signed l.r. *Pascin*

PROVENANCE	Downtown Gallery, New York
	Marie Sterner Gallery, New York
	Downtown Gallery, New York
	ACA Heritage Gallery, New York
	Adler Collection, 1967
EXHIBITED	*Twentieth-Century Americans*, ACA Heritage Gallery, New York, 1967, no. 41.
	Neuberger Museum, 1977, no. 33.
REFERENCE	Neuberger Museum, 1977, p. 62, illus. p. 63.

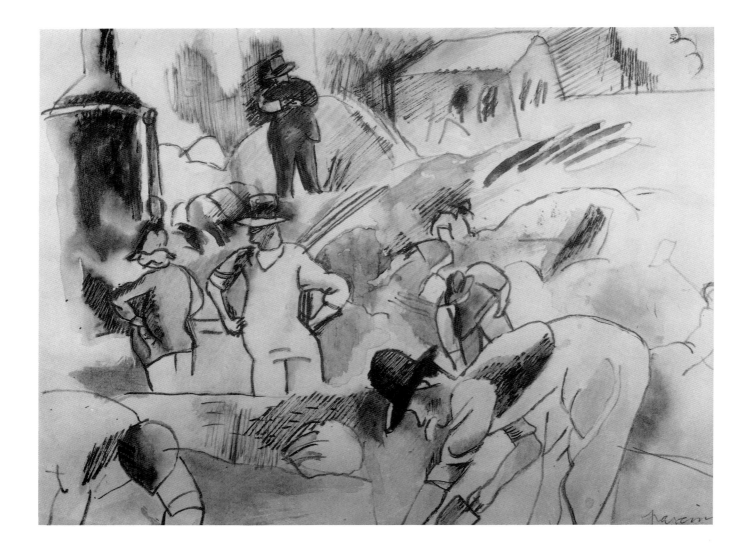

51 WILLIAM McGREGOR PAXTON
1869–1941

After the Bath

ca. 1930
Charcoal
16 x 12 (40.6 x 30.5)
Signed l.r. *PAXTON*

PROVENANCE | Sally DeCamp Moffat, Boston
A. W. Moffat, Jr., Lyme, New Hampshire
Vose Galleries, Boston
Adler Collection, 1987

EXHIBITED | *William McGregor Paxton, 1869–1941*, Indianapolis Museum of Art,
Indianapolis, Ind., 1978–79, no. 82.

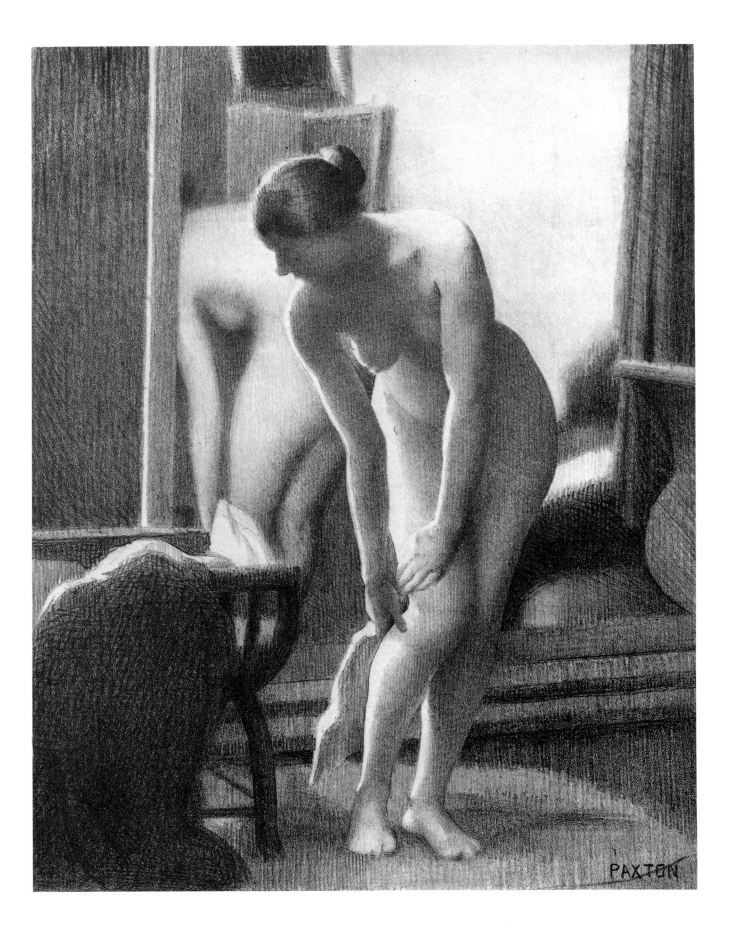

52 THEODORE ROBINSON
1852–1896

Reading
(Study in Monochrome)

1887
Pencil and wash
12⅜ X 10 (31.4 X 25.4)
Signed, dated, and inscribed l.r. *Th Robinson 1887 / Paris*

PROVENANCE | Estate of the artist
| American Art Galleries, New York, Robinson sale
| J. Mortimer Lichtenauer
| Bernard Black Gallery, New York
| Robert C. Graham, Sr.
| Paul McCarron, New York
| Adler Collection, 1984

EXHIBITED | New York Athletic Club, ca. 1910.

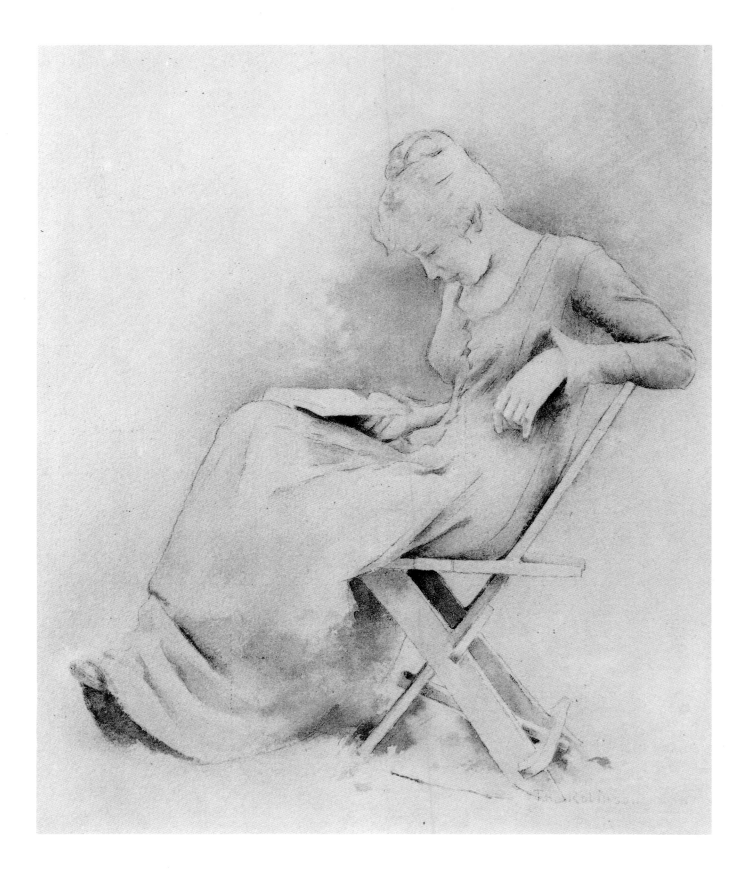

53 HUGO ROBUS
1885–1964

Beach Scene

ca. 1918
Pencil
9¾ x 12 (24.8 x 30.5)
Signed l.r. *HUGO ROBUS*

PROVENANCE | Estate of the artist
Forum Gallery, New York
Adler Collection, 1978

EXHIBITED | *Sculpture (Early Works): Chaim Gross, Gaston Lachaise, Elie Nadelman, Hugo Robus*, Forum Gallery, New York, 1978.
American Works of Art on Paper, 1850–1925, Schenectady Museum, Schenectady, N.Y., 1980, no. 80.

REFERENCES | *American Works of Art on Paper, 1850–1925* (Schenectady, N.Y.: Schenectady Museum, 1980), p. 36.
Roberta K. Tarbell, "Hugo Robus' Pictorial Works," *Arts Magazine* 54 (March 1980), pp. 136–40, illus. p. 138, fig. 17.

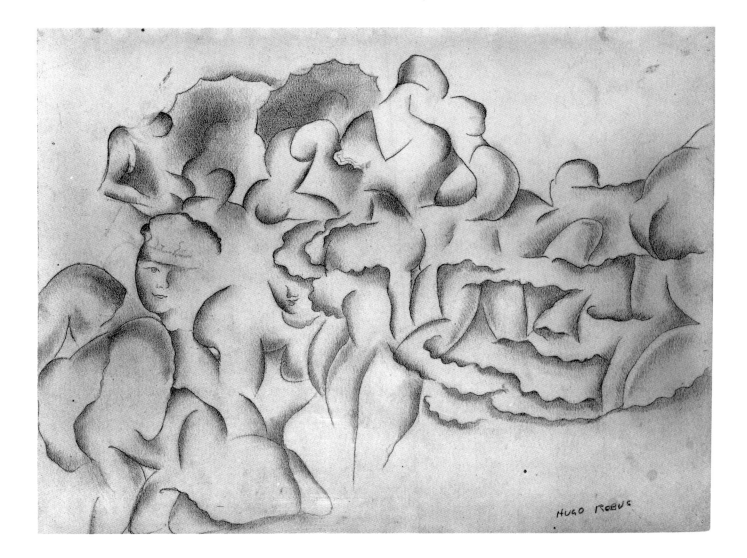

HUGO ROBUS

54 THEODORE ROSZAK
1907–1981

Construction

1937
Ink
6 x 9¾ (15.2 x 24.8)
Signed, dated, and inscribed l.r. *Theodore J. Roszak / N.Y.C. 1937*

PROVENANCE | Estate of the artist
Sara Jane Roszak (the artist's daughter)
Adler Collection, 1983

Theodore J. Roszak
NYC · 1937

55 LUCAS SAMARAS
b. 1936

Untitled

1968
Acrylic
8 x 5 (20.3 x 12.7)
Verso signed and dated u.c. *August 26 / 68 LS*

PROVENANCE
Pace Gallery, New York
Louise Ferrari, Houston, Texas
Sid Deutsch Gallery, New York
Adler Collection, 1986

EXHIBITED
Samaras at the Pace Gallery, Pace Gallery, New York, 1968.
Lucas Samaras, Whitney Museum of American Art, New York, 1972–73,
 no. 254.
Art on Paper, Weatherspoon Art Gallery, University of North Carolina at
 Greensboro, 1981, no. 122.

56 JOHN SINGER SARGENT
1856–1925

Mrs. Claude Beddington

1914
Charcoal
23½ x 18½ (59.7 x 47.0)
Signed l.l. *John S. Sargent*; dated l.r. *1914*

PROVENANCE	Mrs. Claude Beddington
	By descent in the sitter's family
	Christie's, London, sale, 18 July 1972
	Phillip Reiff, Philadelphia
	Thomas Agnew & Sons, London
	Adler Collection, 1983
EXHIBITED	*The Realist Tradition*, Thomas Agnew & Sons, London, 1983, no. 156.
REFERENCES	Mrs. Claude Beddington, *All That I Have Met* (London: Cassel and Company, 1929), pp. 151–56, illus. p. 153.
	Patricia Hills, *John Singer Sargent* (New York: Whitney Museum of American Art, 1986), pp. 270, 275n.

57 STEELE SAVAGE
b. 1900

An Embrace

n.d.
Ink
9⅞ x 6¼ (25.1 x 15.9)
Signed l.r. *STEELE / SAVAGE*

PROVENANCE | Illustration House, South Norwalk, Connecticut
Adler Collection, 1987

58 JOHN SENNHAUSER
1907–1978

Untitled

1941
Ink
21¾ x 16¾ (55.2 x 42.5)
Signed and dated l.r. *John Sennhauser 1941*

❖

PROVENANCE	Estate of the artist
	Martin Diamond Fine Arts, New York
	Hirschl & Adler Galleries, New York
	Adler Collection, 1981
EXHIBITED	*John Sennhauser*, Martin Diamond Fine Arts, New York, 1980.
REFERENCE	"John Sennhauser," *Arts Magazine* 55 (December 1980), p. 54, illus. p. 54.

John Baumbauer 1941

59 EVERETT SHINN
1876–1953

Reclining Female

1904
Charcoal, pastel, and chalk
16 x 19½ (40.6 x 49.5)
Signed and dated l.r. *EVERETT SHINN / 1904*

PROVENANCE	Ferargil Gallery, New York
	Zabriskie Gallery, New York
	Mr. and Mrs. Arthur Marshall, New York
	Zabriskie Gallery, New York
	Adler Collection, 1976
EXHIBITED	Neuberger Museum, 1977, no. 36.
REFERENCE	Neuberger Museum, 1977, p. 68, illus. p. 69.

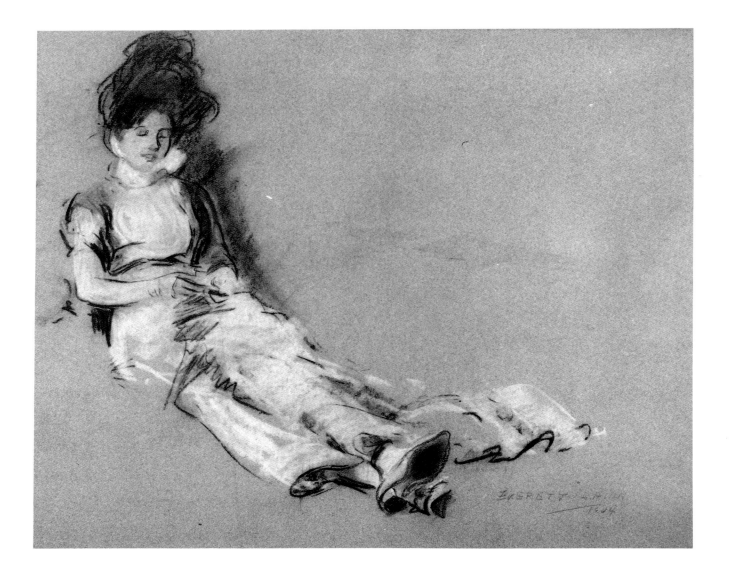

60 WALTER SHIRLAW
1838–1909

Chemistry

ca. 1895
Charcoal
19⅜ x 12½ (49.2 x 31.7)
Signed l.r. *W. Shirlaw*; inscribed l.l. *Chemistry*

PROVENANCE | Childs Gallery, Boston
Adler Collection, 1984

EXHIBITED | *A Memorial Collection of Works by Walter Shirlaw*, City Art Museum, Saint
Louis, Mo., 1910, no. 205.
Memorial Exhibition of Works by Walter Shirlaw, N.A., Corcoran Gallery of Art,
Washington, D.C., 1911, no. 75.

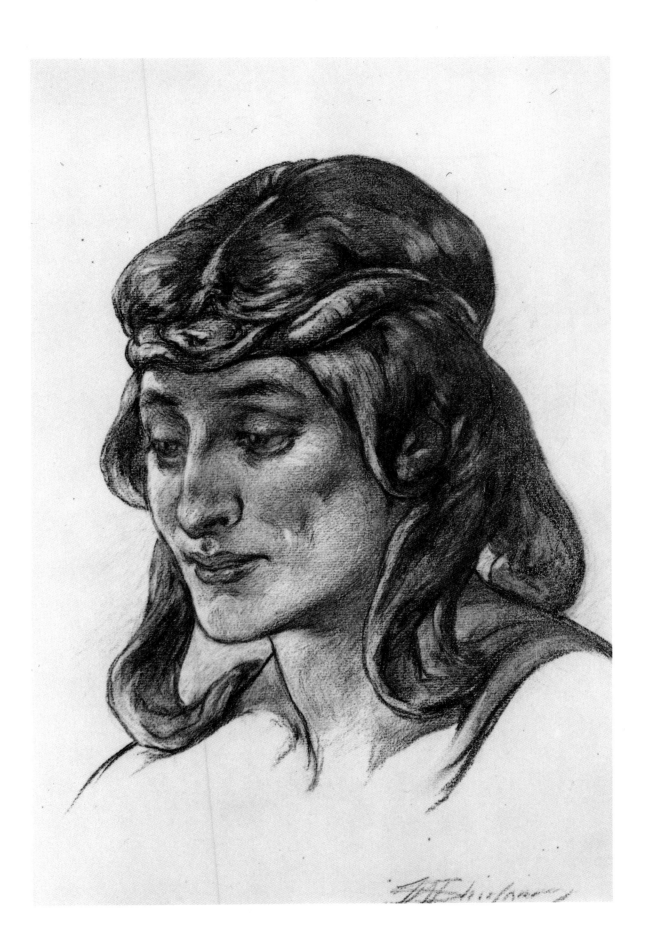

61 JOHN SLOAN
1871–1951

The Couple

1894
Ink and pencil
10 x 6⅝ (25.4 x 16.8)
Monogram l.r. *John / Sloan*

For H. E. Clark, "Sentence of Death," *Philadelphia Inquirer*, 22 July 1894.

PROVENANCE
Estate of the artist
Kraushaar Galleries, New York
Adler Collection, 1967

EXHIBITED
John Sloan, 1871–1951, National Gallery of Art, Washington, D.C., and
 traveling, 1971–72, no. 7.
Graphic Styles of the American Eight, Utah Museum of Fine Arts, University of
 Utah, Salt Lake City, 1976, no. 122.
Neuberger Museum, 1977, no. 37.

REFERENCES
John Sloan, 1871–1951 (Washington, D.C.: National Gallery of Art, 1971),
 p. 56, illus. p. 56.
Neuberger Museum, 1977, p. 70, illus. p. 71.

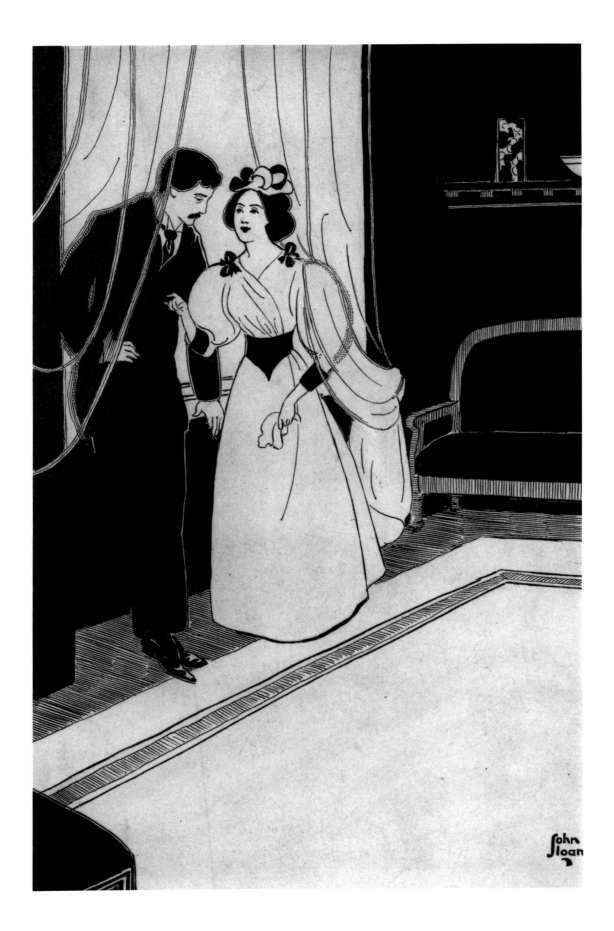

62 JOHN SLOAN
1871–1951

He Was Quickly Placed in His Carriage

1904
Charcoal and wash
10¼ x 14 (26.0 x 35.6)
Signed and dated l.r. *1904 John / Sloan*

For Charles Paul de Kock, *André the Savoyard* (New York: F. J. Quinby, 1904), vol. 2, opp. p. 122.

PROVENANCE

John Sloan Trust
Kraushaar Galleries, New York
Adler Collection, 1976

EXHIBITED

John Sloan, 1871–1951, Whitney Museum of American Art, New York, and traveling, 1952, no. 106.
John Sloan, Smithsonian Institution Traveling Exhibition Service, Washington, D.C., 1961, no. 46.
John Sloan, 1871–1951, National Gallery of Art, Washington, D.C., and traveling, 1971–72, no. 30.
Graphic Styles of the American Eight, Utah Museum of Fine Arts, University of Utah, Salt Lake City, 1976, no. 130.
Neuberger Museum, 1977, no. 38.

REFERENCES

John Sloan, 1871–1951 (Washington, D.C.: National Gallery of Art, 1971), p. 29, illus. p. 75.
Neuberger Museum, 1977, p. 72, illus. p. 73.

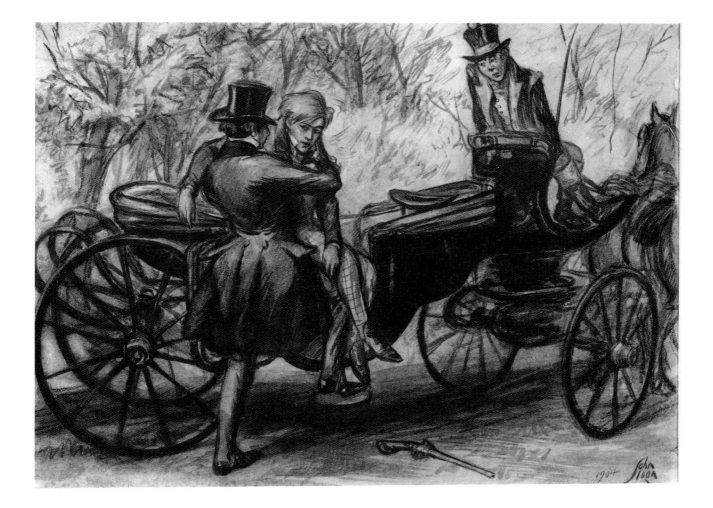

63 SIDNEY L. SMITH
1845–1906

Ellen Terry

1888
Ink
17¼ × 13½ (43.8 × 34.3)
Signed and dated u.r. *S.L.S. / Jan. 1888*; signed and dated l.r.
Sidney L. Smith Jan. 1888

PROVENANCE | Brown-Corbin Fine Art, Boston
Adler Collection, 1987

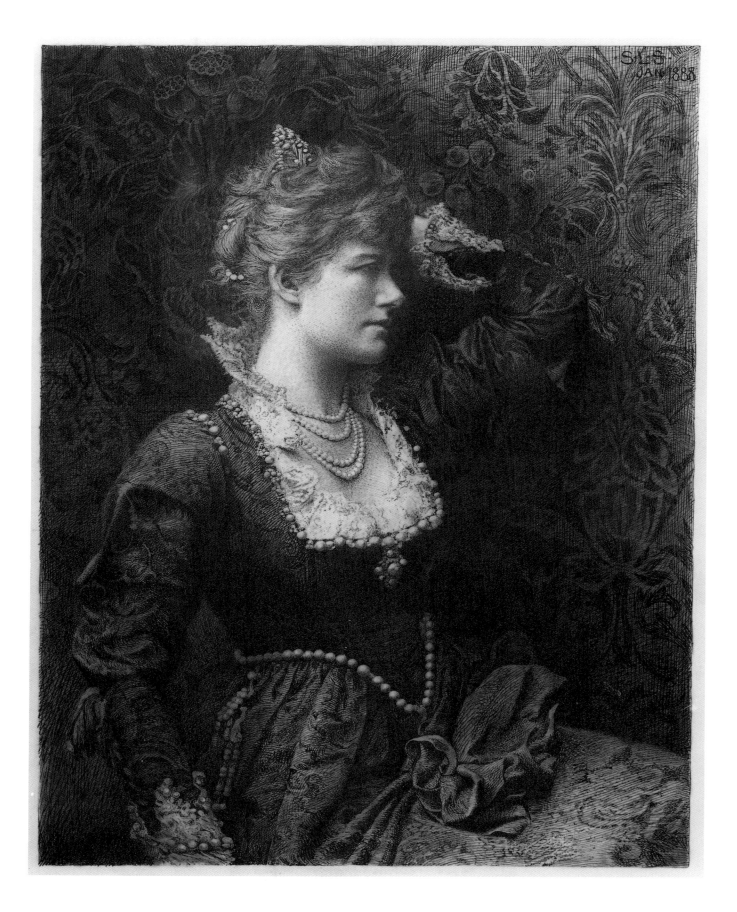

64 SAUL STEINBERG
b. 1914

Saloon, Nebraska

1955
Ink, wash, and crayon
14½ x 23 (36.8 x 58.4)
Signed and dated u.l. *STEINBERG 55*

PROVENANCE	Sidney Janis Gallery, New York
	Private collection, Baltimore, Maryland
	Stephen Mazoh, New York
	ACA Galleries, New York
	Adler Collection, 1971
EXHIBITED	Neuberger Museum, 1977, no. 39.
	Saul Steinberg, Whitney Museum of American Art, New York, and traveling, 1978–79, checklist no. 60.
REFERENCES	Neuberger Museum, 1977, p. 74, illus. p. 75.
	Kathie Beals, ''Two Private Collections Go Public,'' *Westchester Weekend*, 2 December 1977, p. D7, illus. p. D7.

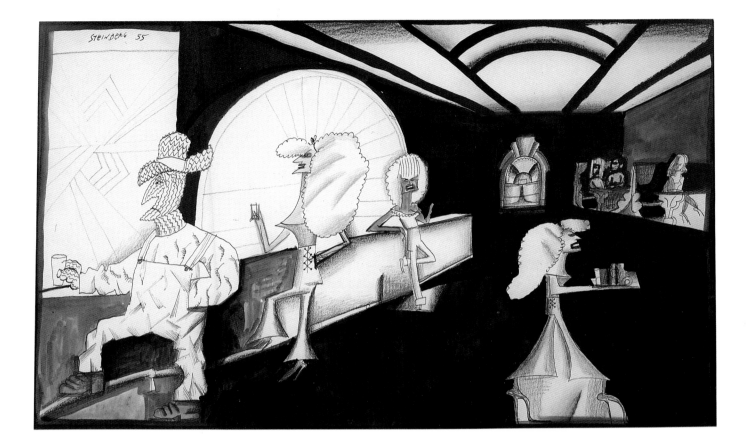

65 JOSEPH STELLA
1877–1946

The Puddler

1908
Pastel and charcoal
19 X 26 (48.3 X 66.0)
Signed, dated, and inscribed l.r. *Joseph Stella / Pittsburgh 1908*

For *The Survey* 22, 2 April 1909, frontispiece (color).

PROVENANCE August Mosca, New York
Gallery EMBAS, New York
Mr. and Mrs. Walter Fillin, Rockville Centre, New York
Davis & Long Company, New York
Adler Collection, 1976

EXHIBITED *Joseph Stella*, Whitney Museum of American Art, New York, 1963, no. 72.
A Family Collects, Department of Fine Arts, State University of New York at Stony Brook, 1964 (not in catalogue).
American-English Drawings and Watercolors, Davis & Long Company, New York, 1977, no. 21.
Neuberger Museum, 1977, no. 40.
Americans at Work and Play, Meredith Long & Company, Houston, Tex., 1980, no. 34.

REFERENCES John I. H. Baur, *Joseph Stella* (New York: Praeger Publishers, 1971), p. 26, illus. no. 14.
Neuberger Museum, 1977, p. 76, illus. p. 77.
Americans at Work and Play (Houston, Tex.: Meredith Long & Company, 1980), p. 17, illus. p. 51.

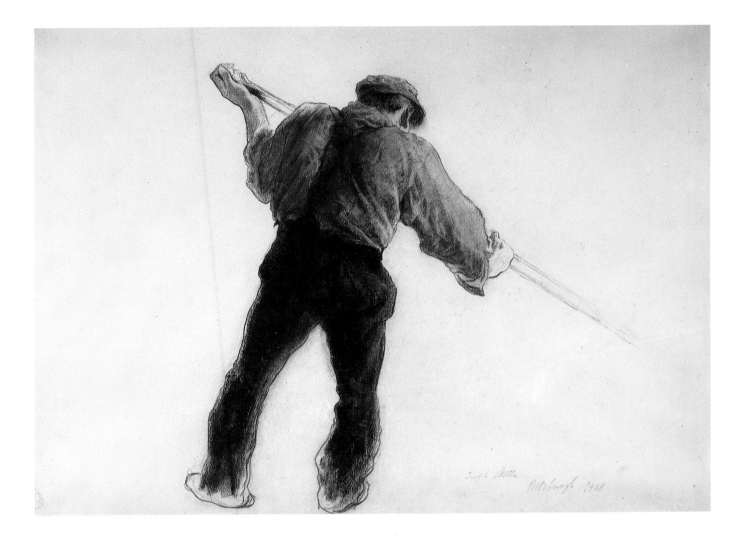

Joseph Stella
Pittsburgh 1908

66 MAURICE STERNE
1878–1957

Girl Seated

1912
Conté crayon and pencil
17 X 12 (43.2 X 30.5)
Signed and dated l.r. *Maurice Sterne / 1912*

PROVENANCE	Clara Lewisohn Rossen, New York
	Mrs. Jean Ransick, New York
	Kraushaar Galleries, New York
	Adler Collection, 1977
EXHIBITED	*Works on Paper*, Kraushaar Galleries, New York, 1976.
	Neuberger Museum, 1977, no. 41.
REFERENCE	Neuberger Museum, 1977, p. 78, illus. p. 79.

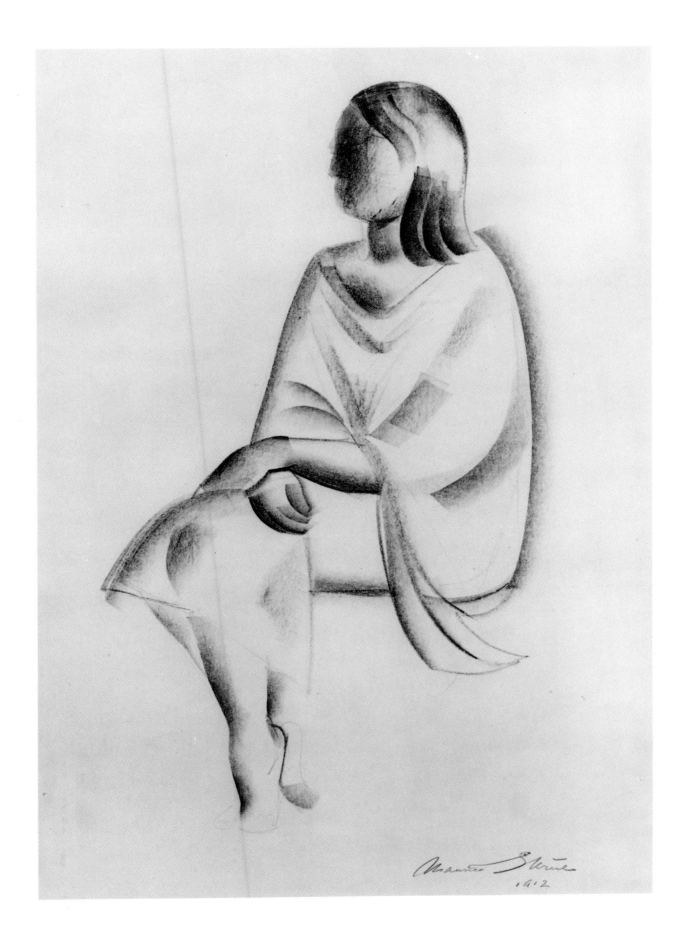

67 ALBERT EDWARD STERNER
1863–1946

My Wife in October 1897

1897
Sanguine
14 x 10 (35.6 x 25.4)
Signed, dated, and inscribed l.l. *my wife / in / October / 1897 /*
Albert E. Sterner

PROVENANCE | Marie Sterner (the artist's wife)
Schumann Foundation, Boston
Ira Spanierman, Inc., New York
Adler Collection, 1978

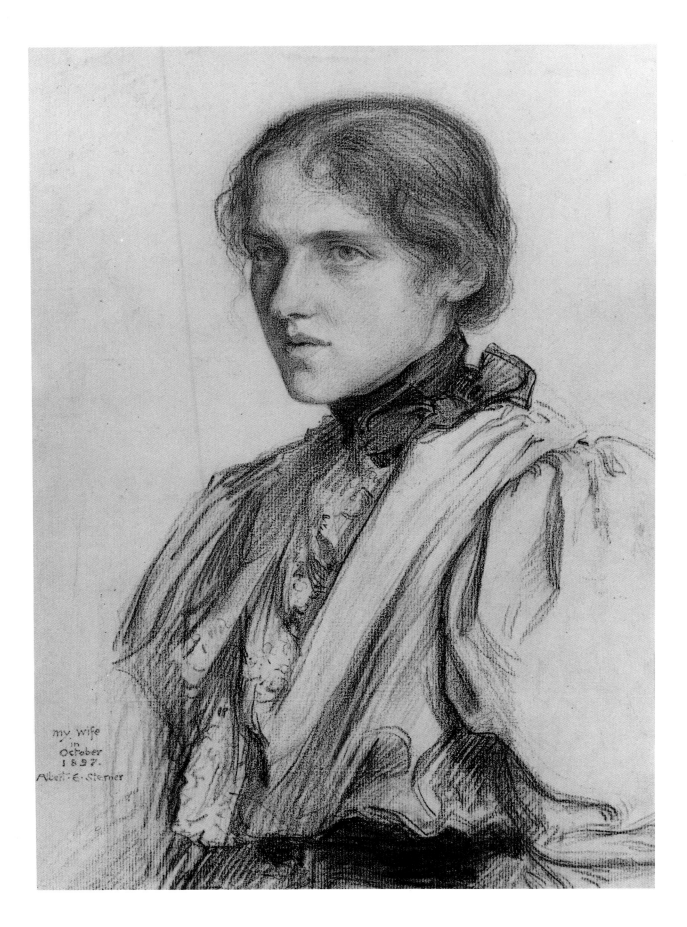

my wife
in
October
1897.
Albert E. Sterner

68 JOHN STORRS
1885–1956

Female Head

ca. 1928
Charcoal
10½ x 9¼ (26.7 x 23.5)

PROVENANCE | Estate of the artist
Robert Schoelkopf Gallery, New York
Adler Collection, 1979

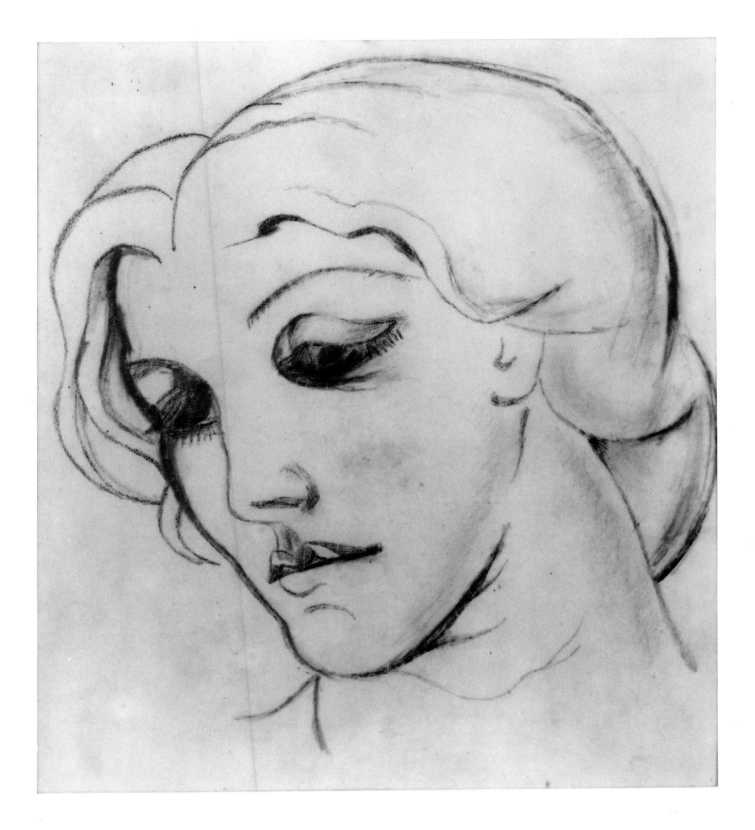

69 JOHN VASSOS
1898–1985

The Bosom of His Father and His God

1931
Gouache
21 X 16 (53.3 X 40.6)

For Thomas Grey, *Elegy in a Country Church Yard* (New York: E. P. Dutton and Co., 1931), p. 77.

PROVENANCE | Robert K. Brown, New York
Jordan-Volpe Gallery, New York
Adler Collection, 1979

70 ROBERT VICKREY
b. 1926

Military Clown

1960
Tempera
24¼ x 20¾ (61.6 x 52.7)
Signed l.r. *Robert Vickrey*

PROVENANCE	Midtown Galleries, New York
	Adler Collection, 1971
EXHIBITED	*Robert Vickrey*, Midtown Galleries, New York, 1960.
	American Watercolor Society, New York, traveling exhibition, 1963–64.
	Instituto de Arte de Mexico, Mexico City, 1968.
	164th Annual Exhibition, Pennsylvania Academy of the Fine Arts, Philadelphia, 1969.
	Robert Vickrey Retrospective, University of Arizona Museum of Art, Tucson, and traveling, 1973.
	Neuberger Museum, 1977, no. 42.
REFERENCES	Robert Vickrey, *New Techniques in Egg Tempera* (New York: Watson-Guptill Publications, 1973), p. 58, illus. p. 58.
	Neuberger Museum, 1977, p. 80, illus. p. 81.

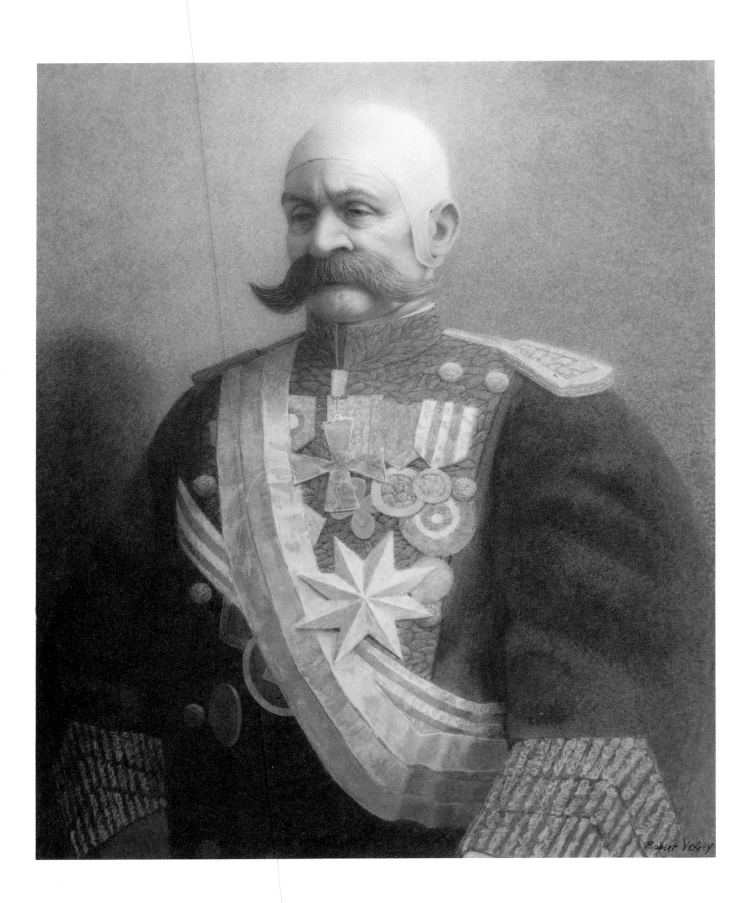

71 FREDERICK J. WAUGH
1861–1940

Three Furies

ca. 1905
Watercolor
6⅝ x 16¼ (16.8 x 41.3)
Monogram u.l. *W*

PROVENANCE Estate of the artist
Coulton Waugh
Edwin A. Ulrich, Hyde Park, New York
Jordan-Volpe Gallery, New York
Adler Collection, 1982

REFERENCE George R. Havens, *Frederick J. Waugh: American Marine Painter* (Orono:
University of Maine Press, 1969), p. 309 n. 34.

72 CHARLES WHITE
1918–1979

Dawn

1960
Wolff crayon
27 x 43 (68.6 x 109.2)
Signed and dated l.r. *CHARLES WHITE '60*

❖

PROVENANCE	ACA Galleries, New York Adler Collection, 1968
EXHIBITED	*Charles White*, ACA Galleries, New York, 1961, no. 11. *Six Black Artists*, Hopkins Center, Dartmouth College, Hanover, N.H., 1968. Neuberger Museum, 1977, no. 43. *Images of Dignity: A Retrospective of the Works of Charles White*, Studio Museum in Harlem, New York, and traveling, 1982–83, no. 17.
REFERENCES	Neuberger Museum, 1977, p. 82, illus. p. 83. *Images of Dignity: A Retrospective of the Works of Charles White* (New York: Studio Museum in Harlem, 1982), pp. 25–26, illus. p. 25.

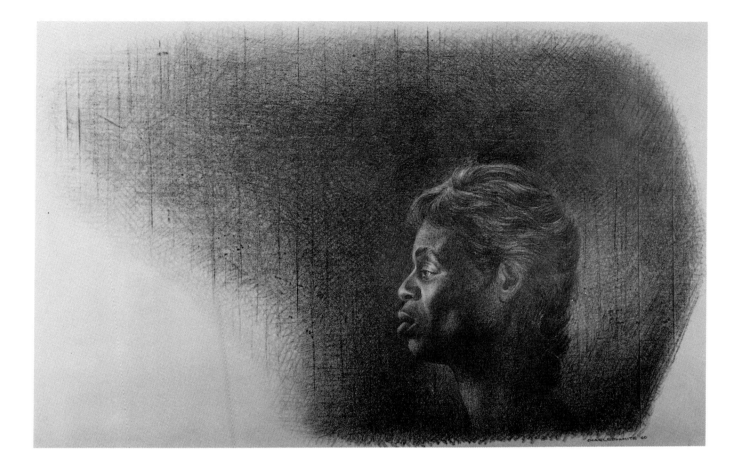

FRANCESCA ALEXANDER
1837–1917

Girl Holding a Locket

ca. 1858
Ink and pencil
10¼ × 7½ (26.0 × 19.0)

❖

PEGGY BACON
1895–1987

The Swan

n.d.
Ink
5 x 6 (12.7 x 15.2)
Signed c.r. *Peggy Bacon*

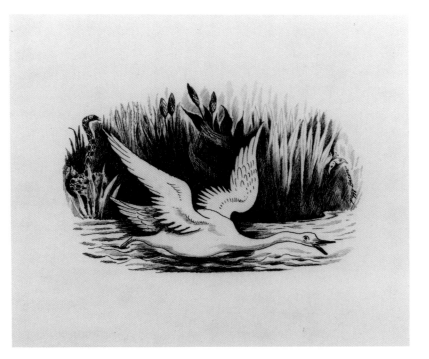

GEORGE BELLOWS
1882–1925

Lady of 1860

1922
Conté crayon
10 X 8⅝ (25.4 X 21.9)
Signed l.r. *Geo Bellows*

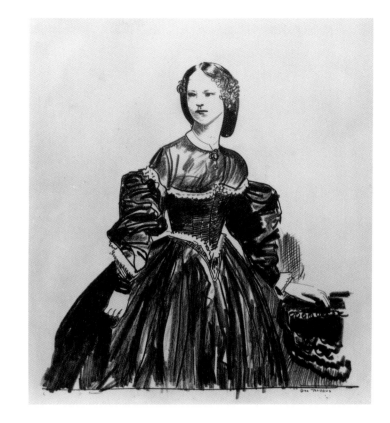

ISABEL BISHOP
1902–1988

Rosalynd

1936
Ink and wash
4 X 3 (10.2 X 7.6)
Signed l.l. *Isabel Bishop*

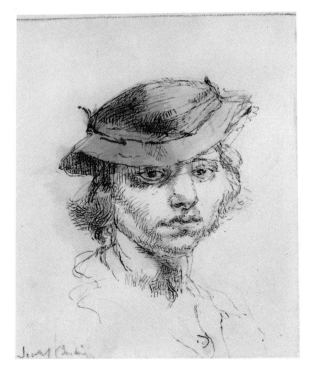

ISABEL BISHOP
1902–1988

Ice Cream Cones

ca. 1938–39
Ink and wash
8 X 5 (20.3 X 12.7)
Signed l.l. *I. Bishop*

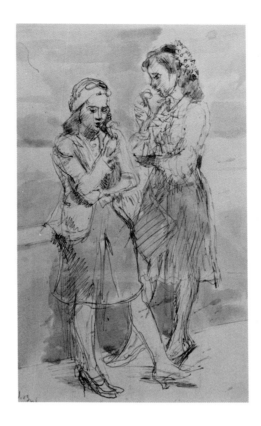

EMIL BISTTRAM
1895–1976

Untitled

1925
Ink
17 X 12 (43.2 X 30.5)
Signed l.r. *EJB.*

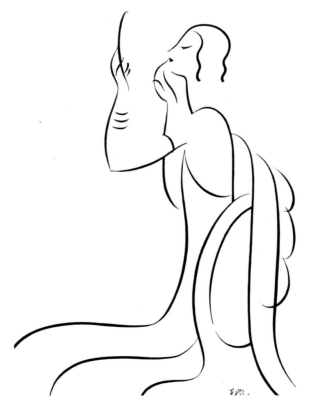

OSCAR BLUEMNER
1867–1938

Soho

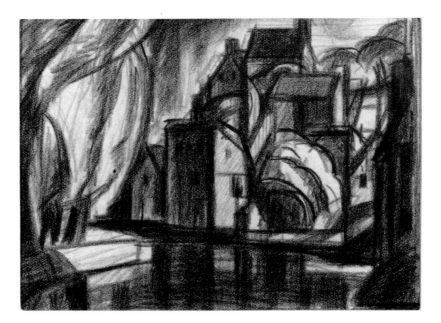

1915
Crayon
3⅛ x 4½ (7.9 x 11.4)
Inscribed on left and right sides

ALEXANDER CALDER
1898–1976

Donkey with Horn

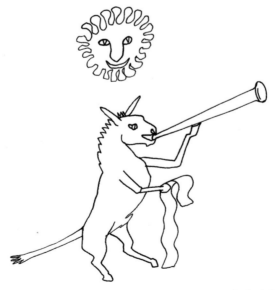

ca. 1944
Ink
14½ x 11⅜ (36.8 x 28.9)
Signed l.r. *A. Calder*

SANTE GRAZIANI
b. 1920

Biglen Brothers #2

1970
Colored pencil
23 X 29 (58.4 X 73.7)
Signed and inscribed c.r.
Sante Graziani after Eakins

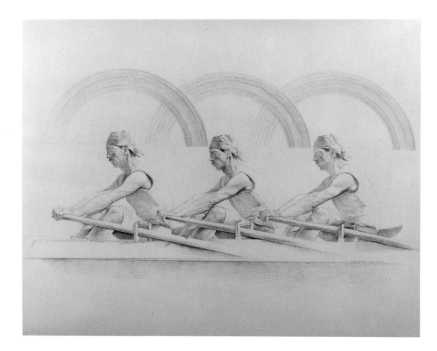

ROBERT HENRI
1865–1929

Blind Musician

1908
Ink
9½ X 7½ (24.1 X 19.0)
Signed l.l. *Robert Henri;* inscribed l.r.
Blind Musician / Madrid

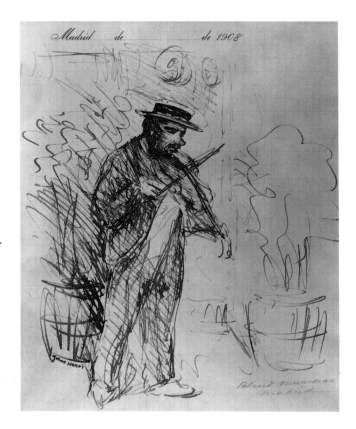

AL HIRSCHFELD

b. 1903

Hair

1968
Ink
24 X 18 (61.0 X 45.7)
Signed and inscribed l.r.
HIRSCHFELD 3

AL HIRSCHFELD

b. 1903

Zero Mostel as Peter Pan

1964
Ink
22 X 15½ (55.9 X 39.4)
Signed l.r. *HIRSCHFELD*

DANIEL RIDGWAY
KNIGHT

1839–1924

*Study for
"The Harvest"*

ca. 1879
Pencil
9¼ × 11¾ (23.5 × 29.8)
Signed l.l. *D R Knight*

REGINALD MARSH

1898–1954

*Fourteenth Street
Girl*

ca. 1944
Watercolor, ink, and wash
10 x 8 (25.4 x 20.3)
Signed l.r. *REGINALD MARSH /
REGINALD MARSH*

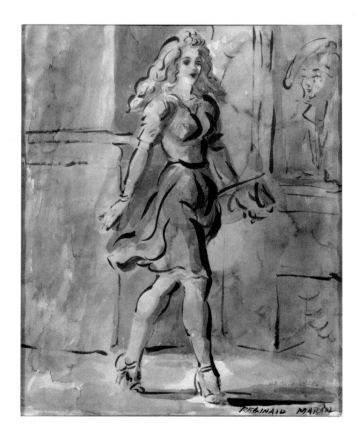

WALTER MURCH
1907–1967

Artificial Crystal

1949
Pencil
10 X 9½ (25.4 X 24.1)
Signed u.r. *Walter Murch*

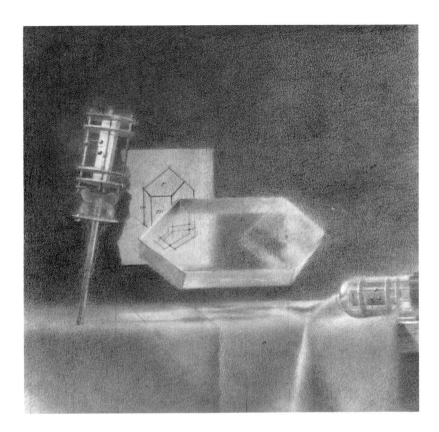

MAURICE STERNE
1878–1957

Head of a Woman

n.d.
Charcoal
18 X 11⅝ (45.7 X 29.5)
Signed l.r. *M.S.*

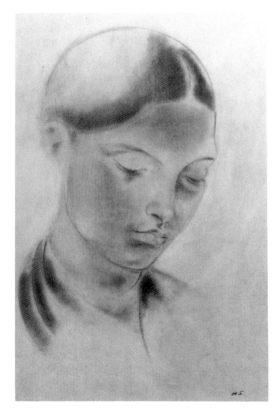

THOMAS SULLY
1783–1872

Portrait Study (recto)
Untitled (verso)

ca. 1820
Recto: wash; verso: pencil
5 X 3¼ (12.7 X 8.3)
Recto signed l.r. *Tho Sully*

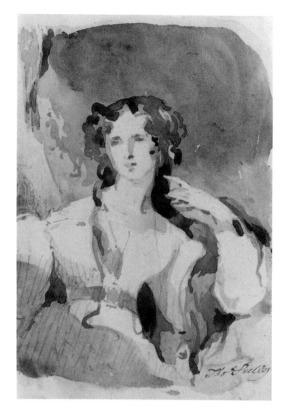

verso

ERNEST TROVA
b. 1927

FM Collage

1967
Collage
10 X 8½ (25.4 X 21.6)
Signed l.r. *trova*

UNKNOWN AMERICAN
ARTIST

*Yellow
Belleflower Apple*

ca. 1850
Watercolor
10¾ x 7 (27.3 x 17.8)
Inscribed l.c. *Yellow Belleflower Apple*

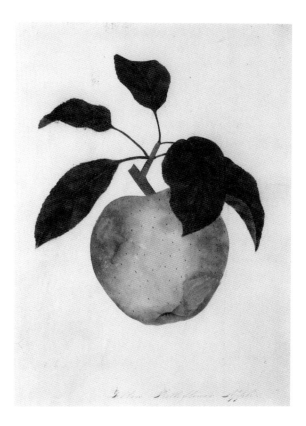

UNKNOWN
PHILADELPHIA
ARTIST

*White-Haired
Man*

ca. 1800
Pastel, wash, and pencil
2 x 1¾ (5.1 x 4.4)

Index

Page numbers in *italics* refer to illustrations.

Adler, Herbert, 9, 10
Adler, Susan, 9, 10
Aesthetic movement, 13, 14
After the Bath (Paxton), 17, 128, *129*
Alexander, Francesca, 22
　Catherine and Cornelia Cruger, 28, *29*
　Girl Holding a Locket, 172, *172*
All Night Mission (Marsh), 114, *115*
All That I Have Met (Beddington), 15–16
Alma-Tadema, Sir Lawrence, 12
American Water Color Society, 10, 13
Analytical Cubism, 20
André the Savoyard (Kock), 26, 150
Art Deco, 9, 20
Artificial Crystal (Murch), 179, *179*
Artist's Mother, The (III) (Hale), 16–17,
　88, *89*
Art Museum of Princeton University, 10
Art Nouveau, 9, 17
Art Students League, New York, 19
Ashcan School, 17–18
Ault, George, 23
　Little White Flower, 23, 30, *31*
Ault, Louise, 23

Babcock, William P., 11
　Female Nude with Cupid, 11–12, 32, *33*
Bacon, Peggy:
　Lady on Front Porch, 34, *35*
　The Swan, 172, *172*
Barbizon School, 11, 12
baroque painting, 17
Beach Scene (Robus), 20, *20*, 132, *133*
Beddington, Ethel M., 15–16
Bellows, George, 17
　Lady of 1860 (14 x 11), 36, *37*
　Lady of 1860 (10 x 8⅝), 173, *173*

Biglen Brothers #2 (Graziani), 176, *176*
Bishop, Isabel, 19
　Ice Cream Cones, 174, *174*
　Rosalynd, 173, *173*
　Two Girls, Study, 19, 38, *39*
Bisttram, Emil, 21–22
　Pearls and Things and Palm Beach, 21,
　　40, *41*
　Time Cycle #1, 21–22, 42, *43*
　Time Cycle series, 21
　Untitled, 174, *174*
Blind Musician (Henri), 176, *176*
Bloch, E. Maurice, 10
Bluemner, Oscar, 23–24
　November Moon (Moonrise), 24, 46, *47*
　Soho, 175, *175*
　Venus, 23–24, 44, *45*
Blum, Robert Frederick, 13
　Study after "A Venetian Market,"
　　13–14, 48, *49*
　A Venetian Market, 14
Bohemian Girl, The (Johnson), 11, *11*
Bosom of His Father and His God, The
　(Vassos), 164, *165*
Boston School, 16–17
Bowdoin, James, III, 10
Boyd, Rutherford, *Self-Portrait*, 50, *51*
Bridges, Fidelia, 22
　Flowering Vine, 22, 52, *53*

Cadmus, Paul, *Old Lady*, 14, 54, *55*
Calder, Alexander, *Donkey with Horn*,
　175, *175*
Carnegie Institute, Pittsburgh, 10
Carter, Susan N., 60
Cassatt, Mary, 14–15
　Study for "Young Women Picking

　Fruit," 14–15, *15*, 56, *57*
　Young Women Picking Fruit, 14–15, *15*
Catherine and Cornelia Cruger
　(Alexander), 28, *29*
Century Magazine, 13, 60
Champney, James Wells, 12
　Indecision, 12, 58, *59*
Chase, William Merritt, 13, 14
　A Countryman, 13, 60, *61*
　*Mrs. William Merritt Chase (Spanish
　　Girl)*, 62, *63*
Chemistry (Shirlaw), 146, *147*
Clark, H. E., 148
Clarke, Thomas B., 10
Construction (Roszak), 134, *135*
Cooper Union, New York, 10
Corcoran Gallery of Art, Washington,
　D.C., 17
Cornell, Joseph:
　The Ocean (recto), 64, *65*
　The Ocean (verso), 64, *64*
Countryman, A (Chase), 13, 60, *61*
Couple, The (Sloan), 17–18, 148, *149*
Courbet, Gustave, 13
Cubism, 20

Davies, Arthur B., *Prancing Nude*, 66, *67*
Dawn (White), 170, *171*
De Camp, Joseph R., 16, 17
　Portrait of Peggy Wood, 16, 68, *69*
Degas, Edgar, 18
Delaunay, Robert, 21
de Longpré, Paul, *Ramblers*, 70, *71*
Dewing, Thomas W., 14, 18
　A Study (Lady with Flowers), 14, 72, *73*
Disney (Walt) Studios, *Mickey Mouse
　(Doden-Doden Da Da-Dah)*, 74, *75*

Donkey with Horn (Calder), 175, *175*
Dynamic Symmetry, 21–22

Elegy in a Country Church Yard (Grey), 164
Ellen Terry (Smith), 152, *153*
Embrace, An (Savage), 140, *141*
Evans, William T., 10

Fagnani, Giuseppe, *Melpomene*, 76, 77
Falconer, John Mackie, 10
Feld, Mr. and Mrs. Stuart P., 10
Female Head (Storrs), 20–21, 162, *163*
Female Nude with Cupid (Babcock), 11–12, 32, *33*
Feuille d'Etudes (Pascin), 124, *125*
Fisher, Ellen Thayer, 22
 The Orange Bloom and the Myrtle Bay, 22, 78, *79*
Fitch, George Hopper, 10
Flowering Vine (Bridges), 22, 52, *53*
FM Collage (Trova), 180, *180*
Fortuny, Mariano, 13
Fourteenth Street Girl (Marsh), 178, *178*
Frieseke, Frederick C., *Morning Room*, 80, *81*
Futrelle, Jacques, 18, 82
Futurism, 20

Gerdts, William H., 12
Gilmore, Robert, Jr., 10
Girl Holding a Locket (Alexander), 172, *172*
Girl Seated (Sterne), 158, *159*
Glackens, William, 17, 18
 Gloriana! Come on, Gloriana!, 18, 82, *83*
Gloriana! Come on, Gloriana! (Glackens), 18, 82, *83*
Goodrich, Lloyd, 9
Gray, Henry Peters, 12
Graziani, Sante, *Biglen Brothers #2*, 176, *176*
Grey, Thomas, 164
Grosz, George, *Mann im Mond*, 84, *85*
Gunfighter (Kent), 102, *103*

Haberle, John, 22–23
 Head of a Man, 22, 86, *87*
Hair (Hirschfeld), 177, *177*
Hale, Lilian Westcott, 16
 The Artist's Mother (III), 16–17, 88, *89*
Hale, Philip Leslie, 16
Halpert, Edith, 23
Hals, Frans, 13
Hambridge, Jay, 21, 26
Harnett, William M., 22
 Iris, 22, 90, *91*
Hassam, Childe, 23
 San Pietro, Venice, 23, 92, *93*
Hatch, John Davis, Jr., 10
Head of a Man (Haberle), 22, 86, *87*

Head of a Woman (Sterne), 179, *179*
Head of a Young Girl (Johnson), 11, *11*, 98, *99*
Head of a Young Woman (Kroll), 9, 108, *109*
Henri, Robert, 17
 Blind Musician, 176, *176*
 Portrait Head of a Woman, 94, *95*
He Was Quickly Placed in His Carriage (Sloan), 18, 150, *151*
Hirschfeld, Al:
 Hair, 177, *177*
 Zero Mostel as Peter Pan, 177, *177*
Homer, Winslow, 12
 Over the Garden Wall, 12, 96, *97*
Hudson River School, 11

Ice Cream Cones (Bishop), 174, *174*
Indecision (Champney), 12, 58, *59*
Ingres, Jean-Auguste-Dominique, 17
Iris (Harnett), 22, 90, *91*

Japanese influences, 15, 17
Johnson, Eastman, 11, 12
 The Bohemian Girl, 11, *11*
 Head of a Young Girl, 11, *11*, 98, *99*

Kandinsky, Wassily, 21
Karolik, Maxim, 10
Kensett, John Frederick, 11, 25
 The Shrine—A Scene in Italy, 10, *11*
 Standing Monk Holding Staff, 10, *11*, 100, *101*
Kent, Rockwell:
 Gunfighter, 102, *103*
 The Pearl Necklace, 106, *107*
 Woman with a Drink, 104, *105*
King, Jack, *Mickey Mouse (Doden-Doden Da Da-Dah)* (for Walt Disney Studios), 74, *75*
Knight, Daniel Ridgway, *Study for "The Harvest,"* 24, 178, *178*
Kock, Charles Paul de, 18, 26, 150
Kroll, Leon, *Head of a Young Woman*, 9, 108, *109*
Kubota, Beisen, 17
Kupka, František, 21

Lacing the Sandal (Lady Tying Her Sandal) (Millet), 12–13, *13*, 118, *119*
Lady of 1860 (Bellows, 14 x 11), 36, *37*
Lady of 1860 (Bellows, 10 x 8⅝), 173, *173*
Lady on Front Porch (Bacon), 34, *35*
Lanman, Charles, 10
Lanning, Edward, 19
Leibl, Wilhelm, 13
Lissitzky, El, 22, 26
Little White Flower (Ault), 23, 30, *31*
Lozowick, Louis, 22, 26
 Machine Ornament #4, 22, 110, *111*
 Smoke Stack, 112, *113*

Luks, George, 17

Machine Ornament #4 (Lozowick), 22, 110, *111*
McQuire, James C., 10
Magriel, Paul, 10
Manet, Edouard, 13
Mann im Mond (Grosz), 84, *85*
Mantegna, Andrea, 19
Marsh, Reginald, 19
 All Night Mission (recto), 114, *115*
 Fourteenth Street Girl, 178, *178*
 Progress Hotel (verso), 114, *114*
Masaccio, 19
Matulka, Jan, 23
 Still Life with Guitar, Pears, Wine Pitcher, and Glass, 116, *117*
Melpomene (Fagnani), 76, *77*
Mickey Mouse (Doden-Doden Da Da-Dah) (Walt Disney Studios, inked by Jack King), 74, *75*
Military Clown (Vickrey), 166, *167*
Miller, Kenneth Hayes, 19
Millet, Francis Davis, 12
 Lacing the Sandal (Lady Tying Her Sandal), 12–13, *13*, 118, *119*
 Reading the Story of Oenone, 12, *13*
Millet, Jean-François, 11
Mondrian, Piet, 21
Moore, Albert, 13
Morning Room (Frieseke), 80, *81*
Mrs. Claude Beddington (Sargent), 15–16, 138, *139*
Mrs. William Merritt Chase (Spanish Girl) (Chase), 62, *63*
Munich Akademie, 13
Murch, Walter, 23
 Artificial Crystal, 179, *179*
 Study for "Cyclops," 120, *121*
Museum of Fine Arts, Boston, 10, 16
My Wife in October 1897 (Sterner), 15, 160, *161*

Nadelman, Elie, 19–20
 Seated Figure, 20, 122, *123*
Nation, The (magazine), 13
National Academy of Design, New York, 10, 14
Neuberger Museum, Purchase, N.Y., 9, 12
New Masses (periodical), 22
New-York Drawing Association, 10
Norton Gallery of Art, West Palm Beach, Fla., 24
November Moon (Moonrise) (Bluemner), 24, 46, *47*

Ocean, The (Cornell):
 recto, 64, *65*
 verso, 64, *64*
Old Lady (Cadmus), 14, 54, *55*

Orange Bloom and the Myrtle Bay, The
 (Fisher), 22, 78, *79*
Over the Garden Wall (Homer), 12, 96, *97*

Pascin, Jules:
 Feuille d'Etudes, 124, *125*
 Street Workers, 126, *127*
Paxton, William McGregor, 17
 After the Bath, 17, 128, *129*
Pearl Necklace, The (Kent), 108, *109*
Pearls and Things and Palm Beach
 (Bisttram), 21, 40, *41*
Philadelphia Inquirer, 17, 148
Philadelphia School of Design for
 Women, 17
Phillips Academy, Andover, Mass., 10
Picasso, Pablo, 20
Portrait Head of a Woman (Henri), 94, *95*
Portrait of Peggy Wood (De Camp), 16, 68,
 69
Portrait Study (Sully), 180, *180*
Prado, Madrid, 13
Prancing Nude (Davies), 66, *67*
Precisionism, 23
Pre-Raphaelites, 14, 22
Princeton University Art Museum, 10
Progress Hotel (Marsh), 114, *114*
Proun drawings (Lissitzky), 22
Puddler, The (Stella), 18–19, 156, *157*

Ramblers (de Longpré), 70, *71*
Reading (Study in Monochrome)
 (Robinson), 14, 130, *131*
Reading the Story of Oenone (Millet), 12,
 13
Realism, French, 17
Reclining Female (Shinn), 18, 144, *145*
"Researches into Harmonious
 Relationships of Forms and Volumes"
 (Nadelman), 20
Robinson, Theodore, 14
 Reading (Study in Monochrome), 14,
 130, *131*
Robus, Hugo, 19
 Beach Scene, 20, *20*, 132, *133*
 Untitled, 20, *20*
Rosalynd (Bishop), 173, *173*
Roszak, Theodore, *Construction*, 134,
 135
Ruskin, John, 22

Saloon, Nebraska (Steinberg), 154, *155*
Samaras, Lucas, 23

Untitled, 136, *137*
San Pietro, Venice (Hassam), 23, 92, *93*
Sargent, John Singer, 15, 16, 17, 25
 Mrs. Claude Beddington, 15–16, 138,
 139
Saturday Evening Post, 18, 82
Savage, Steele, *An Embrace*, 140, *141*
School of the Museum of Fine Arts,
 Boston, 16
Seated Figure (Nadelman), 20, 122, *123*
Self-Portrait (Boyd), 50, *51*
Sennhauser, John, 20
 Untitled, 20, 142, *143*
Shinn, Everett, 17, 18
 Reclining Female, 18, 144, *145*
Shirlaw, Walter, *Chemistry*, 146, *147*
Shrine—A Scene in Italy, The (Kensett),
 10, *11*
Sloan, John, 17–18
 The Couple, 17–18, 148, *149*
 He Was Quickly Placed in His Carriage,
 18, 150, *151*
Smith, Sidney L., *Ellen Terry*, 152, *153*
Smoke Stack (Lozowick), 112, *113*
Society for Improvement in Drawing, 10
Society of Painters in Pastel, 10
Soho (Bluemner), 175, *175*
Soyer, Moses, 9
Spear, Athena T., 20
Standing Monk Holding Staff (Kensett),
 10, *11*, 100, *101*
Steinberg, Saul, *Saloon, Nebraska*, 154,
 155
Stella, Joseph, 18–19
 The Puddler, 18–19, 156, *157*
Sterne, Maurice:
 Girl Seated, 158, *159*
 Head of a Woman, 179, *179*
Sterner, Albert Edward, 15
 My Wife in October 1897, 15, 160, *161*
Still Life with Guitar, Pears, Wine Pitcher,
 and Glass (Matulka), 116, *117*
Storrs, John, 19, 20–21
 Female Head, 20–21, 162, *163*
Street Workers (Pascin), 126, *127*
Studio, The (magazine), 13
Study, A (Lady with Flowers) (Dewing),
 14, 72, *73*
Study after "A Venetian Market" (Blum),
 13–14, 48, *49*
Study for "Cyclops" (Murch), 120, *121*
Study for "The Harvest" (Knight), 24, 178,
 178

Study for "Young Women Picking Fruit"
 (Cassatt), 14–15, *15*, 56, *57*
Sully, Thomas:
 Portrait Study (recto), 180, *180*
 Untitled (verso), 180, *180*
Survey, The (journal), 18–19, 156
Swan, The (Bacon), 172, *172*
Symbolism, 15

Tarbell, Edmund C., 16
Three Furies (Waugh), 168, *169*
Time Cycle #1 (Bisttram), 21–22, 42, *43*
Time Cycle series (Bisttram), 21
Transcendental Painting Group, 21
Trova, Ernest, *FM Collage*, 180, *180*
Turner, J. M. W., 23
Two Girls, Study (Bishop), 19, 38, *39*

Untitled (Bisttram), 174, *174*
Untitled (Robus), 20, *20*
Untitled (Samaras), 136, *137*
Untitled (Sennhauser), 20, 142, *143*
Untitled (Sully), 180, *180*

Vassos, John, *The Bosom of His Father and*
 His God, 164, *165*
Velázquez, Diego, 13
Venetian Market, A (Blum), 14
Venus (Bluemner), 23–24, 44, *45*
Vickrey, Robert, *Military Clown*, 166, *167*

Walt Disney Studios, *Mickey Mouse*
 (Doden-Doden Da Da-Dah), 74, *75*
Waugh, Frederick J., *Three Furies*, 168,
 169
Weinberg, H. Barbara, 12
Whistler, James McNeill, 14
White, Charles, *Dawn*, 170, *171*
White-Haired Man (unknown
 Philadelphia artist), 181, *181*
Whitney Museum of American Art,
 New York, 9
Woman with a Drink (Kent), 104, *105*
World's Columbian Exposition,
 Chicago, 15

Yellow Bellflower Apple (unknown
 American artist), 181, *181*
Young Women Picking Fruit (Cassatt),
 14–15, *15*

Zero Mostel as Peter Pan (Hirschfeld),
 177, *177*

Photograph Credits

Photographs of works in the Adler Collection are by Geoffrey Clements, with the exception of the following:

eeva-inkeri: pages 123, 133.
John Ferrari: pages 47, 99, 111, 113, 145.
Helga Photo Studio: pages 51, 53, 81, 87, 89, 97, 119, 143.
Lowy: pages 29, 175.
Eric Pollitzer: pages 155, 176.
Sydney W. Newbery: page 139.
Studio/Nine, Inc.: page 157.